The

HONORABLE
OBSCURITY
HANDBOOK

The

HONORABLE
OBSCURITY
HANDBOOK

solidarity & sound advice
for writers & artists,
BEING
a compendium by one of that kind,
of essays, correspondence,
autobiography & marginalia
WITH
ample quotations
affording guidance &
consolation from the ages

M. ALLEN CUNNINGHAM

ATELIER26 BOOKS : samizdat series vol.1

Cover design by Nathan Shields
Book design by M.A.C.

isbn-13: 978-0-9893023-0-2
Second Atelier26 printing, fall 2014

Library of Congress Control Number: 2013906866

The author thanks Nicholas Delbanco, Cynthia Ozick, and
Jayne Anne Phillips for kind permission to quote from
their works. Further permission acknowledgments appear
on p.218.

Printed in the U.S.A. on recycled, acid-free paper

Atelier26 Books: *samizdat series* Vol.1

Atelier26

*"A magnificent enthusiasm, which feels
as if it never could do enough to reach the
fullness of its ideal; an unselfishness of
sacrifice, which would rather cast
fruitless labour before the altar than
stand idle in the market."*—John Ruskin

Atelier26books.com

to J,
may you grow up
seeing some honor in it all

Contents

IV. ALERTNESS

V. A Brief Autobiography

VI. Je Est un Autre

VII. Defensiveness

VIII. A Solidarity Index

The author gratefully acknowledges the editors of publications where some of the material in this book first appeared: Kathleen Holt at *Oregon Humanities Magazine*; Kevin Larimer at *Poets & Writers*; Jeff Baker at the *Oregonian*; Lee Thomas at *Fiction Writers Review*; Cheston Knapp at *Tin House*.

Additional bountiful thanks to: Tim Clark, Soul Shelter co-founder, fellow writer, and friend; Evyn Mitchell at ACLU Oregon; Ben George, conversationalist extraordinaire; Jon Lauderbaugh, model reader and generous book benefactor; Literary Arts, for the moral encouragement and financial assistance of a fellowship; and, at the heart and center of all my good fortune, K.

This book was made possible by an Individual Artist Fellowship from the Oregon Arts Commission, for which the author is inexpressibly grateful.

He feared that his whole scheme had degenerated to,
even though it had not originated in, a social unrest
which had no foundation in the nobler instincts; which
was purely an artificial product of civilization.

—THOMAS HARDY, *Jude the Obscure*

Dollars damn me; and the malicious Devil is forever
grinning in upon me, holding the door ajar. ... What I
feel most moved to write, that is banned,—it will not
pay. Yet, altogether, write the other *way I cannot. So the*
product is a final hash, and all my books are botches.

—HERMAN MELVILLE,
letter to Nathaniel Hawthorne, June 1851

It is sometimes through the willful, superfluous actions
of individuals that societies discover their powers.

—KENNETH CLARK, *Civilization*

I think that's a good thing for anybody to be, is a
brilliant failure. I can't stand success. It's obscene!

—LEONARD COHEN,
Canadian Broadcasting Corp., Nov. 12, 1963

I.

INTRODUCTION

HONORABLE OBSCURITY : A PRIMER

There is a dilemma at the heart of any life dedicated to inspiration over income, creativity over commerce. In my life, that dedication is art — namely, literature — or more namely, fiction writing. The economic hazards of art-making cannot be overestimated, and since fiction writing, next to poetry, is the least lucrative of the arts (in my past six years of sustained work I've earned virtually nothing), the writer or aspiring writer is peculiarly charged to accept, and over time even affirm, a condition of impecuniousness. Wildly lucky name-grade novelists notwithstanding, most writers — even those with one or more novels to their credit — must labor, often for years, sans payment. In our increasingly doctrinaire publishing climate, even the finest among them labor without any guarantee of eventual publication or income. The greater number of literature's real practitioners (those who have not let cynicism or status anxiety eat away their gifts) work under such conditions. To paraphrase Emerson on the subject of his ideal American scholar, these artists ply the slow, unhonored, and unpaid task of observation. But being cashless and devoid of cachet, they are, according to the meritocracy, inferior to those who earn their keep. Lesser intelligences — or weaker wills — they appear to be (we

might as well say it) apostate Americans. Can what they do be classed, by any stretch of the imagination, as work?

"One has to be poor unto the tenth generation," said the poet Rainer Maria Rilke. "One has to be able at every moment to place one's hand on the earth like the first human being." Writing these words in 1907, Rilke had already created some of the world's most beautiful poems. And yet he was unknown and would remain impoverished. Why ever would a writer work for years on end at something unlikely to lead to success? A natural question, considering our Zeitgeist, in which art is increasingly classified as a career. Witness the "professionalization" of literature through this country's numerous creative writing degree programs (822 of them, by Louis Menand's reckoning in the *New Yorker* a few years ago), through high profile book tours, astronomical author advances, chic Upper East Side publication day soirees, and rampant self-promotion. Given this obsession with social ambition and the acquisition of institutionally ratified "skill," even in the literary arts, the young working novelist who fails to prove upwardly mobile begins to look socially suspect, and perhaps delusional — not only to the culture at large, but within the literary "industry" itself.

We've come a long cultural distance from Rilke, for whom economic betterment and art were never a unitary whole, and never expected to be. To him, adept in displacement and deprivation, art meant always beginning anew. Art was loneliness, day labor, obedience,

patience. Art was, as the poet's alter ego Malte Laurids Brigge puts it, "making use of the fact that no one knows you." Rilke had come of age in fin-de-siècle Europe, and was one of the last to embody the role of full-time artist as known in Europe's patronage system for centuries. Although he forever lacked secure financial footing, he had — more significantly — the ears, empathy, and encouragement of a few generous aficionados.

In our very different era, it's no surprise that Rilke-bashing has become an irresistible sport among the literati. Commentators swarm to accuse the poet of posing in order to curry favor with the cultured rich of his day, or to dodge his domestic responsibilities. Surely no one could be *that* "poetic," that irrationally sensitive, that desperate for solitude and indifferent to advancement. Raking Rilke's personal life for damage done to others, these decriers pronounce him: "Toxic company" (Clive James); "Selfish, snobbish, and decidedly unsympathetic" (Sven Birkerts); "A cold and calculating egotist, covering his selfishness with the royal robes of art" (William Gass); "A coward, a psychic vampire, a crybaby...and a virtual parody of the soulful artiste" (Michael Dirda, the *Washington Post*); Rilke, we are told, "lived a life full of evasions and betrayals... [and] was not a strong soul" (Brian Phillips, the *New Republic*).

But just take a turn through Rilke's letters, where his agonizing confessional manner is everywhere apparent, and the idea of some seductive Rilkean villainy becomes roundly absurd. All his life, Rilke affirmed openly to all

who knew him that his aloofness, solitude, and absent interest in career allowed him to create his best poetic works, several of which we now celebrate as being among the greatest in the world. From earliest youth his "pose" never faltered, in which case we cannot call it a pose. As for Rilke's friends and loved ones, whether by natural sympathy or by dint of his painfully honest testimonials in letters and books, they did not resent him his predilections. And they weren't simply dupes. They understood him.

More than specious moral revulsion, the contempt heaped upon Rilke today reveals that a wholehearted betrothal to one's unprofitable and non-popularizing art as work is becoming, in a sense both personal and sociological, purely anachronistic (not to mention the patronage of such work). It appears we're at risk, artist and non-artist alike, of conclusively forgetting a civilizational truth postulated nicely by art historian Kenneth Clark: "It is sometimes through the willful, superfluous actions of individuals that societies discover their powers." In America it has always been the spiritual task of the artist to defend his art to a private self who wished it to be more notable or remunerative; today's task increasingly means defending one's art to a culture that *expects* it to be those things and more.

Whether you come to the desk as a writer in secondhand clothes or a CEO in clover, your prescribed oracle is now the same: the dollar. You have before you, like everybody else, the great playing field of the competitive marketplace. You must put your shoulder to the fray

and reap a respectable yearly income — or, failing that, at least amass conspicuous honors, appointments, grants, awards — else admit that what you do is not really work. A hobby, maybe, this words on paper business. A spinsterish diversion that is quaint and slightly embarrassing in its Victorian echoes. Not work. Artists of late, enthusiastically subscribing to the "career track," offer collusion with and reinforcement of the new pragmatism. As Eric Larsen notes in his fulminating treatise *A Nation Gone Blind: America in an Age of Simplification and Deceit,* "Inner and outer, public and private, artwork and ad, conscience and collaboration" have never been so interchangeable. What is your mission statement? What are your credentials? Art making, we're all led to understand, is not a way of life, a calling, a sacrificial act — we've grown up since the age of Rilke's Europe, of mollycoddling "the imagination"; we've learned self-respect. Red-eyed, brain-sore, hunchbacked novelist, ask thy bank account whether you're wasting your time; ask thy "reputation"; heed their replies. Doth they whisper: "Earn thy MFA!" "Get thee a teaching job!" "Network more!" Then jump to it or jump ship.

Says critic Lee Siegel in his book *Falling Upwards: Essays in Defense of the Imagination,* "The general anxiety now is that if you don't have a gallery, a movie about to be released, or a six figure advance for a book soon after college, you have bungled opportunities previously unknown to humankind. … Instead of the artist patiently surrendering his ego to the work, he uses his ego to rapidly direct the work…toward the success that

seems to be diffused all around him like sunshine."
Siegel's bright-eyed hankerer, to continue an admittedly
hyperbolic tone, is a capitalist stand-in for the spirited
artist of old — a kind of new literary forty-niner, brain
ablaze with Fifth Avenue rumors of the latest Big Deal,
the who's who of agents, bestseller lists and film
options, eager to demonstrate the skills of self-promo-
tion, of being interesting — or even better, incendiary —
in interviews. I find it hard to imagine the injunction of
John Keats, one of literary history's great unprivileged,
having any relevance in such a racket: "The genius of
Poetry [read: art] must work out its own salvation in a
man; it cannot be matured by law and precept, but by
sensation and watchfulness in itself — that which is
creative must create itself."

No doubt our forty-niner meets with Keats in litera-
ture class, yet how remote in their comparatively simple
epochs the great dead ones can seem, how altitudinously
ensconced, their fame assured to attentive posterity.
Keats went to the grave a definitive pauper, convinced
of his life's failure. But anthologized beside Byron and
Shelley, the Keatsian life work loses, in some alarming
way, this frame of chronic indigence, anonymity, and
day to day anxiety. Once you're dealing with canonized
art, as John Dewey cautions in *Art As Experience*, it
tends to become all but divorced from the often fretful
"human conditions under which it was brought into
being." We tend to forget that Ezra Pound earned less
than two dollars a year in royalties. And if it's true that
the generations have pasted onto these bygone lives an

assurance of literary immortality that in their own perplexed time the likes of Keats and Pound never came near to claiming, then the latter-day student is apt to adopt some confused presumptions about the nature of art and artistic success. Once stripped of their poverty, obscurity, and the painful solitude that gave rise to their works, our long dead artists can no longer whisper — in their true, often tormented voices — to the artists yet to come.

Deaf to the counsel of these artistic forebears, career-hungry, and crisply certified in the skill set of a genre, the literary forty-niner cooperates unwittingly in the cultural degradation of his own art. Or in the perpetuation of ideas that, by parsing artists into "The Successful" and "The Obscure," rouse disaffection at the family table. Once — never mind the artist's career prospects — art was work, pure and simple. The artists at least believed so. Now your primary ticket to the status and dignity of worker is, it would appear, a CV replete with workshops attended, notable mentors consulted, fellowships held, and, when it comes to publishing a book, salability demonstrated and choice blurbs at the ready, or what's known in the lingo as a "platform." What was it Whitman scribbled in his notebook while warming up to the first lines of *Leaves of Grass*? "Do not descend among professors and capitalists." Quaint. He was hardly a success, of course.

Our ruling cultural values may induce humiliation in anyone who would (Emerson again) "in silence, in severe abstraction...hold by himself; add observation to

observation, patient of neglect, patient of reproach, and bide his own time — happy enough if he can satisfy himself alone that this day he has seen something truly." But here is the bald, eternal truth about the work of the art-maker: it is work of *unknowingness*. Rarely stream-lined, rarely efficient, necessarily isolating, and always painful, it is work accomplished most often despite the artist's life circumstances, and in the absence of the pragmatism, the knowing and surety, which normalcy insists must frame our days.

After most of a lifetime spent scraping by, secure retirement prospects are unlikely to await. Meanwhile, there's the substantial psychological risk of being pegged as an oddball in backyard barbecue discussions pertaining to career leverage or new pieds-à-terre in vacation markets (I once passed a pained dinner hour among other writers whose conversation actually re-volved around the latter). For shucking it all and doing your own thing you might earn only fickle praise and more constant scorn. Maybe you'll get good at your thing and appear regularly in print or public exhibitions — still, it's unlikely to become a sustainable livelihood. In short, you are unlikely to become what's commonly called a "success."

So why write novels or poetry? Why value the writ-ten arts? Why dignify even unpaid creativity as work? In my twelfth grade year, I was blessed by a brilliant En-glish teacher who enlivened literature as I and my class-mates had never guessed was possible. One memorable day, while effusing about Wordsworth, Mr. Hagar

paused to pose the questions above. The more eager among us flailed for a right-sounding answer: "Because poetry makes you a better person!" "Because reading helps you think critically!" "Because being literate gives you political power!" Such answers had grains of truth to them. Mr. Hagar listened and smiled bemusedly. Then, in his impassioned style, he lifted a finger and proclaimed, "Because literature and art are wonderfully *impractical!*"

Our employment is often a pragmatic necessity. We work in order to live. But much of what we live for is essentially impractical: childrearing, travel, fine cuisine, good music, immersion in nature, the reading of scripture. Life's greatest joys often provide little or no material advantage, but nurture and enlarge the human spirit. These we might call "The Wonderful Impractical." Literature is one of these joys. What's more, if "aesthetics is the mother of ethics," as poet and Nobel Laureate Joseph Brodsky argued, then good literature may even help to create a more moral world.

They're out there. Day and night, in any given locale, they're hard at it. Our novelists and poets, who strive away in shabby rooms, reverse the formula daily: they live in order to work. But their work helps us to live. They win no honors and receive no grants. They hobnob with no famous elders. Yet they comprise, in their dedication and lack of "prospects," a new Cult of Carts like that which raised the cathedrals at Chartres, Amiens, Reims — a force of pure, unpaid human creativity in service to something larger and more lasting than them-

selves. Their incentive? Destiny. Their inspiration when faced with privation and self-doubt? Bygone literary gods who struggled much the same. Their rewards: How to name them? But they more than mitigate the annoyances of thin wallets, scant praise, nonexistent reputations. Quietly, faithfully, these writers' late-paid, ill-paid, or altogether unpaid works go into the world untrumpeted, unreviewed, and largely unbought, to lay bare the same fallacy denounced by Annie Dillard a quarter century ago: "that the novelists of whom we have heard are the novelists we have."

To our finest struggling, unheard-of artists, I would never suggest that hunger and want are your duty, that to be a good artist you must remain a pariah. May you never don the hair-shirt the marketplace decrees: the belief that whatever cannot be profitably commoditized deserves to be ignored, unhelped; that the worthy ones never require assistance; that what will rise will rise of its own power.

Still, a Rilkean life, vouchsafed by its contemporaries, is not presently possible; those cultural values vanished with Habsburg Europe. And today, the work of novel and story requires what art has always required of its practitioners. Can you accept, asks the work, all absence of reward? Can you answer to calling over career? Can you value and protect the fruitful pains of solitude — in Susan Sontag's words, "the kind of inwardness that resists the modern satieties" (of, one wishes to add, endless connectivity, success formulas,

and seven figure book deals)? Can you avow that it's possible to be glad no one knows you?

Rilke was right. The work asks. Will you answer well?

<div align="right">— Oregon Humanities Magazine, 2010</div>

Young person anywhere, in whom something is rising up that causes you to shiver, make use of the fact that no one knows you. And if they contradict you — those who take you for a nobody; and if they give you up completely — those with whom you would associate; and if they pretend you don't exist on account of your dear ideas: what is this clear danger, which holds you together inside yourself, compared to the cunning hostility of later fame, which makes you impotent by scattering you? Beg no one to speak of you, not even contemptuously. And when time goes by and you mark your name coming around amongst people, take it no more seriously than everything else you find in their mouths. Think: it has become poorly. And put it away from you. Take another name, any, so that God can call you in the night. And hide it from everyone.

—RAINER MARIA RILKE,
The Notebooks of Malte Laurids Brigge
(transl. Cunningham)

II.

VAGARIES

IN THE ABSENCE OF YES

Yesterday brought a new rejection letter to my door. It arrived, as do they all, in a white business envelope self-addressed some months before. The rejection was of the paper-saving variety favored by today's quarterlies, a Xeroxed quarter-page containing a terse, preprinted message amounting to: "Nope, not this time and probably not ever."

The submission in question was an essay that took me a year to write, which shaped up to be a learned, provocative, and personal exploration of a subject in which I hold established credentials (the long, humbling writing process allows me to say so without delusion or inordinate pride). Upon its completion, I prepared submissions and dispatched them to the mail with the warming prophetic tingle that often accompanies work well done: this thing was bound to see publication someplace worthy of it, i.e., one of our more distinguished literary magazines.

The first several rejections rolled in, each accompanied by a personal note from an editor complimenting the essay and then professing equal remorse for refusing it. I sealed, stamped, and mailed further submissions.

Ambivalent editorial compliments answered almost every one. So I revisited the work, scrutinizing it for

defects, poised to improve it. But without complacency, without smugness, I was simply reaffirmed of its readiness for publication, its power. I just liked it. Naturally, we are all capable of self-deception and must guard against it always. But whether you've "workshopped" a piece in the traditional writing program sense or run it past your merciless inner editor ad nauseum, the beauty — and curse — of an inescapably solitary discipline like writing is that, in the end, you must rely on your gut. How crucial, how arduous it is to tone the muscle of critical discrimination till you may stand firm and believe in the worth of what you've produced without being hardheaded or willfully blind. To strike that precarious balance is a talent useful in all aspects of life; it's the trait we often refer to as faith or trust — and occasionally love.

More submissions … more conflicted No's. And yesterday's note was the sixteenth rejection. *Sixteen.*

It's worth noting that a short story I've been sending around for more than two years recently garnered its thirty-seventh rejection — this on the heels of three rejected fellowship applications and a handful of queries flatly ignored by the editors I'd sent them to.

Two years ago I treated the subject of rejection on a blog: "Because rejection is such a fundamental part of my vocation, I've learned to look at it in a special light. As I see it, each no that arrives by mail, rather than being an explicit stumbling block, is actually a stepping stone bringing me closer to a yes."

That has the benefits of optimism, but feeling as I feel today, I know it can't be the whole story. It fails to account for the fact that sometimes (often?) the "yes" never arrives — just flat out fails to come along, for sometimes it doesn't matter how hard one labors, how seriously one regards the task at hand, or how deserving one's work may be. The proverbial road of one's career, even for those already "on their way," is rarely a route of ever increasing ease. In my own case, I'm discovering to my dismay that the road can actually get rougher. Even with two novels, a score of shorter publications, a share of honors, and the ostensible stamp of validation thought to come of critical acclaim, good work continues to languish in the lonely room of its composition. That "yes" — most longed for, most necessary — is never guaranteed. Meanwhile, in light of my firm publication history, every "no" that comes my way seems to mean more than it ever did before; no longer a mere formality, each demands to be taken as an explicit condemnation of my work. This is an eventual — and for me, unforeseen — peril of getting published in the first place, and throws light on a paradox about the life of a writer: where the private undertaking of his or her art requires the writer to cultivate high sensitivity — a dependably thin skin — the public act of producing and marketing that art requires a hide of bovine thickness.

But having served a term as reader on the masthead of two prominent literary magazines, I can confidently report that deserving work (as far as periodicals go, anyway) is frequently, even commonly, obscured and

passed over in sluice tides of Manila envelopes. Everybody's got a blind spot or two, the most experienced editors included. Moreover, one eternally unappealing fact of the publishing marketplace is that forces both cynical and wholly arbitrary frequently come to bear on the making of decisions. Fashions, favors, nepotism, "insider trading," ad revenue, moral presumptions, allergies, upset tummies, hangovers, serotonin deficiencies, and above all personal taste can stand between ourselves and whatever we or our work rightfully deserve.

For my own part, faced with the refusal of editors to stand by writing they openly admire, I sometimes brood, Hamlet-like, and accuse my epoch. "The time is out of joint!" Might I be living and writing in the wrong era? Is my stuff unfashionable? I recall the consoling wit of Wallace Stegner, one of our greatest writers — and one perennially bewildered by the vagaries of editorial and critical preference (the *New York Times*, after completely ignoring Stegner for years, finally featured him in a backhanded article about "Western" writers, tacking the caption "William Stegner" to his photo). "Literary fashion," Stegner wrote in a personal letter of 1972, "is a virus for which there is no vaccine, and if you happen to grow up a smallpox type in a cholera time, you might just as well reconcile yourself to faint praise, faint damns, faint yawns. … I thought I had a chance with this last one — my last chance, probably. It was a feather in the Grand Canyon, and I'm a little too old to rally up and try 'em again." As it happened, the book Stegner

was referring to, *Angle of Repose*, went on the same year to win the Pulitzer Prize in fiction.

Or I tell myself: think of Henry James. In 1895 James wrote: "I have felt, for a long time past, that I have fallen upon evil days — every sign or symbol of one's being in the least wanted, anywhere or by anyone, having so utterly failed."

That was soon after his first foray into writing for the London stage, the upshot of which was the humiliating flop of his play *Guy Domville*. And yet today, of course, we know he managed to keep working. Earlier in his journal James breathlessly goads himself:

> I am in full possession of accumulated resources
> — I have only to use them, to insist, to persist, to
> do something more — to do much more — than
> I have done. The way to do it … is to strike as
> many notes, deep, full, and rapid as one can. …
> Go on, my boy, and strike hard. … Try every-
> thing, do everything, render everything — be an
> artist, be distinguished, to the last.

And there's the rub. Call us the Struggling Established, the Honorably Obscure, the Foolhardy Diligent — we who face the timeless frustrations of the writing life as faced by old Henry back in 1895 or Stegner in 1972. We're firmly in a tradition of existential literary angst — a realization which, even if it makes nothing easier, can somehow console.

A century after James, in a little essay called "First Books," the great short story writer Andre Dubus offered his own Jamesian statement of faith (read closely and you see these guys are talking about more than writing):

> All these truths and quasi-truths ... about publishing are finally ephemeral. ... What is demanding and fulfilling is writing a single word, trying to write le mot juste, as Flaubert said; writing several of them, which become a sentence. When a writer does that, day after day, working alone with little encouragement, often with discouragement flowing in the writer's own blood, and with an occasional rush of excitement ... the treasure is on the desk. If the manuscript itself, mailed out to the world, where other truths prevail, is never published, the writer will suffer bitterness, sorrow, anger, and, more dangerously, despair. ... But the writer who endures and keeps working will finally know that writing the book was something hard and glorious, for at the desk a writer must try to be free of prejudice, meanness of spirit, pettiness, and hatred; strive to be a better human being than the writer normally is, and to do this through concentration on a single word, and then another, and another. This is splendid work, as worthy and demanding as any, and the will and resilience to do it are good for the writer's soul.

As for me, after filing away my essay's latest rejection, I sit down to my own journal and write the following:

> It's not a matter of what you deserve, and — more to the point — certainly not a matter of what you *think* you deserve. All that matters is what you're committed to, and how you honor that commitment, and — sometimes — what you are blessed by.

<div align="right">

— *Poets & Writers,* 2011

</div>

LETTER *to* AN AUTHOR FRIEND CONCERNING THE VAGARIES OF SUBMISSIONS

Dear C,

As you well know, a writer wants most of all to feel understood — and among writers novelists seek this more than any, don't we? Despite our shy, hermetic ways we're a starved and eager crew. I became extremely cognizant of this during my first stay at a writer's colony last summer, surrounded every breakfast and supper by fifteen other writers, all of us earnest, awkward, and cagey in our happiness at being thrown together — and somehow mistrustful of togetherness, cautious of our hunger for it.

This secretive, solitary, often isolating art demands the counterweight of comprehension — being comprehended is the novelist's version of being a part of things. And yet for all but one percent of us this understanding comes so rarely, or reaches us only vaguely, fragmentarily, as echo or suggestion. As I've mentioned, I sent you my manuscript because while it has been skimmed and scattered on many a befuddled editor's desk (or computer screen, God forbid) over these last nine months, I knew you would comprehend it, C. But you've done far more: you've taken the time and care to show *how* you've comprehended it. Where editors for whatever addled, mercenary, or blindly subjective reasons have

failed and disappointed the book, you have bolstered it. This writer feels his readerly faith restored. And his book, much rejected thing, feels better about itself.

It can only be *itself,* in the end. Far from personal dejection, this has been the effect of the rejection — I mean submission — process overall: my own redoubled sense of the book's completeness and *self*ness, and yet of some injury or indignity repeatedly done to the book by "professionals." In other words, far from feeling cast down (having done my utmost and written to the best of my powers the book that wanted to be written), I feel, in a parental way, worried for this poor, pure-hearted, over-looked, jabbed and bullied manuscript. How will it find its footing in the world? Who (what editor and readers) will befriend it?

How many publishers have seen it, you ask? I have the tally at about 22 so far. Beyond rote rejectionese like "I was not passionate enough about this," here, for indignant fun, is an exhibit of some things editors have said, plus my own addenda.

> "I'm not sure I'm confident enough Cunningham can sustain the narrative clearly enough over such a long time span to be satisfying."

(It's obvious this guy didn't finish it, so he wouldn't know either way.)

> "I thoroughly enjoyed the scope of the piece … [but] I didn't find it varied enough in theme."

(Themes crash course: clocks/years/generations; tele-
graph/letters/communication; secrecy/silence/silhou-
ettes/shadows; Manifest Destiny/western movement/
American vastness/spiritual vacancy; Civil War/family
war/American violence; Old World/New World; tech-
nology/personal reinvention; Benjamin as latter-day
Hamlet ... [but you, of course, saw these, C!]))

> "I felt that he was often forgetting the reader. ...
> I had trouble connecting with the characters. ... I
> just never felt the narrative taking on momentum
> and pulling me through ... [but] I was fascinated
> by the details of the camps and the letters from
> the war!"

(How could she like the war letters and not find that *they*
provided momentum? They're at the heart of the plot,
after all.)

> "I found the narrative thread here rather difficult
> to follow and had a hard time with the letters —
> they took me away from the characters, and the
> moment, in a way that I found disruptive."

(Ditto letters & momentum)

> "The structure of the book often reveals the
> characters' fates before we truly become
> attached to them ... and this tends to diminish
> the drama of the developing plot."

(She didn't read attentively enough to notice what the main plot really is.)

"It feels very 'historical' to me and sometimes that category comes with a feeling of heaviness."

(Can't heaviness be *good*? Isn't Hardy heavy? James? Toni Morrison?)

I'm not merely crazy or disgruntled, am I, to respond as I do above? Your own response to the book, C, reaffirms that I'm not — that the problem the novel has faced is faulty or distracted reading. In that sense there is, I realize, some danger in ascribing much sincerity to these rejecters' comments. Too often such comments are made with the aim not of communicating insight so much as defending an entrenched position. A few other editors have — subtly and not so subtly — alluded to my "track record" as reason for rejection. And so many of the responses, like the above, contradict one another, that it all comes out a wash. Or, if there is a moral, it's this: *Writer, Follow Thy Own Star, and Be Thee Patient!*

I've been reading Lionel Trilling lately, and the other day I was struck by something he wrote in 1947 describing a contemporary deification of "reality" (as opposed to flights of imagination) in literary taste. For Trilling, this wish to narrowly define and enshrine "reality" showed a cultural mistrust of "the internal" which, eerily, seems to me to hold true in today's literary marketplace: "Whenever we detect evidences of style

and thought we suspect that reality is being a little betrayed."

Then, in an essay by Cynthia Ozick (love this lady) about Saul Bellow, I find this wonder: "The art of the novel...is in the mix of idiosyncratic language — language imprinted in the writer, like the whorl of the fingertip — and an unduplicable design inscribed on the mind by character and image."

The art of the novel, that is, thrives on the ineluctable peculiarities of style. Singularities of vision, we could say. Or, to come back to Trilling, the "internal" stamp. But don't you get the sense, as I do, that to write like *oneself*, to show the whorl, is to earn in the current marketplace editorial scorn? — that is, unless you're an established DeLillo or Ondaatje. Aren't we fiction writers made to feel (subliminally through the culture, or overtly via editors) a little ashamed of pliant language or structure, as if we're making unreasonable demands upon readers? As if the definition of a fine and viable novel is that which sounds like every other book, or no book in particular, that which meets the reader at face value, sans subtext, nuance, subtlety of theme, already fully explicated on every page — i.e., ideal for dipping in and out of while text-messaging or downloading a TV show. According to the general sentiment (at least among major publishers), peculiarity of style is a form of lying or of extreme egotism — and we see what they do to liars and egotists nowadays, in this Age of Disgraced Memoirists.

But I, for one, am a reader who likes a novel to make some demands upon me. And demanding novels *do* see the light — some anyway, even ones authored by obscurer writers.

Goodness, now I'm afraid I must apologize for writing a jeremiad where I meant only to express appreciation. But hopefully this can bring with it, more than idle complaint, a bit of solidarity, because I know your own beautiful work has lately braved the same climate. I do really appreciate you giving your time, C, and treating the manuscript to such a respectful reading. I feel that you've seen in it all that I would hope for a reader to see.

While my prospects of earning any decent advance on this one have evaporated, the passionate objective remains to simply see the thing into print. A strange position to find myself in, I must say, having felt all along that this is my strongest — and certainly my most plot-driven (and wouldn't that mean "commercially" viable?) — book.

Oh, but meanwhile there remains only and as ever the work of doing one's best and holding one's ground. And of clearing one's head of all these matters once at the desk. The work itself is what one has. So much else is beyond one's control.

Meanwhile, too, we have friendship.

In friendship, with great thanks,

—M

FROM E-MAILS *to* HENRY DAVID THOREAU'S LITERARY AGENT

1. *Walden; or, Life in the Woods* (rethink title?) seems to us the kind of book most enjoyably read in the forest, but because the scarcity of electrical outlets in the forest will preclude robust e-book sales, I'm afraid we must decline at this time.

2. In our judgment, Mr. Thurrow [sic] has fabricated a great portion of his text. The battle of the ants, for example, is obviously heavily embellished. In characters like the cheerful woodchopper, too, Mr. Thurrow draws mere caricatures and stretches plausibility to the breaking point suggesting that all these Simple Folk were conveniently at hand to help him illustrate his arguments. We cannot afford the scandal of yet another debunked memoir, so we're going to pass at this time.

3. Mr. Thoreau's opening chapter "Economy" is overlong and fails to provide any fresh insights concerning the present downturn.

4. It's our understanding that Mr. Thoreau does not use e-mail. We can't devote the excessive time required for dealing with an author who does not have a gmail or at least a yahoo account.

5. The author's philosophical tangents are distracting and hard to follow. What we want to know is: Were there bears in the woods? Did he ever fall through the ice or fall on his hatchet? Did he chew hallucinogenic mushrooms? Was there homoerotic tension with the woodchopper? Etc.

6. His poetry seems self-indulgent and out of place and will alienate nonfiction readers.

7. I really liked his bits of poetry. Would Mr. Thoreau consider foregoing his preachments and collecting his verse instead? Something along the lines of *Chicken Soup for the Rustic Out-doorsman's Soul*?

8. What did Mr. Thoreau eat in his cabin in the woods? To whom did he pray? Who did he love? If he were to restructure his book around these concerns, we might reconsider.

9. Hello, I am Ms. M_____'s assistant and I have enjoyed it has been my pleasure to read [sic] this ms. I decided in the end however that the author tells too much instead of showing. When he does

show, he starts to get carried away in long descriptions about trees, chickadees, and skunk cabbages. Did he ever think about attending an MFA program? I had some very admirable teachers in mine and now thanks to those skills and an incomparable network I am in publishing!

10. It is very unlikely that any readers in our social media age will identify with a narrator so passionately extolling solitude.

11. The author needs to decide what kind of book he is writing. As far as I can tell, his current text is a muddled conglomeration of political tract, cultural polemic, memoir, nature article, self-help manual, and fairy tale. Obviously, that is far too many things to ask of one single book and consequently this manuscript feels bloated and incoherent.

12. He goes overboard with his references to history and religion — these are way too numerous and needlessly arcane (the Colossi of Memnon? Twelve Labors of Hercules? Hygeia?). It's a poor stylistic choice, also, to imitate a bullfrog by writing, "tr-r-r-oonk, tr-r-r-oonk, tr-r-r-oonk."

13. It has come to our attention that the author's prior book, *A Week on the Concord and Merri-*

mack Rivers, sold fewer than 300 copies. This is a less than desirable track record (to put it mildly) and, we believe, reflects upon the overall problems in his work: a crabby voice, a provincial subject matter, and of course, given his lack of platform beyond the community lecture circuit, the great unlikeliness of strong sales. Has Mr. Thoreau considered blogging?

— *The Oregonian,* 2010

LETTER *to* AN EDITOR FRIEND CONCERNING FUTILITY

Dear G,

Herewith, one of the world's lovelier anachronisms: a palpable letter. Truth be told, I could not resist a run of a few lines on my newest toy. She's a handsome old Royal H-H, circa 1960 — a behemoth and a byoot, and my how she cackles when you tickle her glossy green keys (every "serious" writer is obliged a fancy ode to his amanuensis, eh?). I got her for a song from a store in St. Johns where the sweater-clad salesmen hitch their trousers high and sport pompadours to boot. I'm still getting a hang of her, so this comes to you errors and all. "Lift and stab," instructed the salesman. I stagger and jab, but she doesn't mind, and gives me a chime at every return. Sad how laptops bereave us of that little bell.

Enough about Royal. I wished mainly to send along the enclosed chapter by the profoundly searching writer Paul Zweig. Have you heard of this guy? I hadn't. This is from his book *Departures**, his last, which was published posthumously. Cancer took him, all too soon, back in the mid-eighties. Enclosed chapter is his first-person account of his battle with terminal illness. More than that, however — and more to the point — it's an

* See "Sex, Death, & Art-Making as Living," page 126

47

astonishing profession of faith concerning the literary life. I was about halfway through *Departures* when you and I spoke on Thanksgiving Eve and I bent you ear groaning about my "futility problem" in the matter of my work at hand. "Keep the faith," you counseled as we rang off. The very next evening, apropos of some providence, I guess, I read this chapter. Zweig writes: "Did the world need another book? I knew that wasn't the question," and goes on to articulate with the elegant authority of a dying man the insensible, undeniable urge that compels any of us to throw a work into the void (superficial or sublime, all works are bound there, as we know too well; Do not lay up treasures on earth, etc.).

During our talk on the phone, you will recall, I soliloquized about the "lasting" (or non-lasting) nature of this work that so consumes my hours and thoughts. To which you listened kindly. I suspect you were too good to chide me, but Jesus, can I tumble off the beam sometimes! What kind of nonsense was all that? See, what gets me groaning is one half exhaustion, sure, but a stronger half excuse-making.

Whether my work lasts is, naturally enough, no business of mine, and really couldn't be more irrelevant, given that *this* living day, the one elapsing *now* (and tomorrow, again, *now*) is the thing that needs paying attention to.

Ah, none of which is to say that I am now reconstituted, reformed, and back to the grindstone, where the quality of such living days does always find its improvement. Slowly I crawl, inch by inch. ... First, I guess, I

needed the romancing of a Royal H-H. But I will get back there soon, and will remember well as I return that

> What there is to conquer
> By strength and submission, has already been discovered
> Once or twice, or several times, by men whom one cannot hope
> To emulate — but there is no competition —
> There is only the fight to recover what has been lost
> And found and lost again and again: and now, under conditions
> That seem unpropitious. But perhaps neither gain nor loss.
> For us, there is only the trying. The rest is not our business.

There's Mr. Eliot, humble bank clerk by day, on the subject of today's lesson, class. Those last lines even form a graffito above my desk in the shed, where I see them daily. Yet my "futility problem" would have its run of me. …

Anyhow, pardon another soliloquy. And enjoy the Zweig chapter. Onward.

—M

It is not childish to live with uncertainty, to devote oneself to craft rather than a career, to an idea rather than an institution. It's courageous and requires a courage of the order that the institutionally co-opted are ill-equipped to perceive. They are so unequipped to perceive it that they can only call it childish, and so excuse their exploitation of you.

—DAVID MAMET, *True and False*

III.

In Practice

SLOW & STEADY, PT. 1:
What Resists Us Helps Us

R estriction breeds invention!" While fielding audi-
ence questions at a public reading, the gifted
fiction writer Ethan Canin remarked thusly on the use-
fulness of limitations — and even roadblocks — for any
fiction writer. This, of course, is an idea all creative
souls can seize upon.

Canin, author of the now classic 1988 short story col-
lection *Emperor of the Air* (his auspicious debut at age
28), was talking about restriction in terms both of the
nitty-gritty components of a short story *and* the overall
circumstances of a writer's life. A teacher at the Iowa
Writers' Workshop, Canin said he's fond of prompting
his students to write a short story that will "make the
reader cry over a pair of socks" — a supreme example of
creative restriction. He's always surprised and delighted
by the results.

Some years ago I read an interview with Canin in
which he advocated a regimen likewise dependent upon
restriction. He claimed he deliberately restricted himself
to one half-hour per day of writing time. *(A measly
half-hour?!)* The amount of productivity generated by so
minuscule an allowance, he said, was astonishing.

This calls to mind some comments by another fine
contemporary author, Annie Proulx, from a 2003 read-

ing in San Francisco. Proulx restricts herself creatively by deliberately avoiding *all regimens*. Much like Canin, rather than bemoaning the scarcity of time, she embraces it and lets it augment her energies. But unlike Canin, Proulx works scattershot. She's done this so long she knows no other way:

> I don't have a regular writing regimen. I write whenever I can get the time — and usually it's a matter of shoehorning some work in somewhere or it doesn't happen. I'll write if I wake up at 2:00 a.m., and I often do. ... I've never kept a set writing schedule. That sounds really bad to me.

Naturally, Proulx is an extreme example. Not everybody can be so dedicated — or free of other obligations — as to relinquish structure entirely. But she makes a helpful point, underlining the main one here.

As Canin's notion goes, imposed limitation — in ideas or images, as well as in actual time to create — can galvanize the imagination in ways that, paradoxically, the writer given unlimited creative freedom may seldom experience. (Canin's own widely read story, "Accountant," itself revolves around a peculiarly moving pair of socks.)

This notion is not new, of course. The adage "resistance sparks the flame" suggests something similar. But such ideas have fallen out of fashion in a contemporary moment geared toward job obsession, "live/work life-

styles," and all or nothing dispositions in most endeavors.

The great lot of us, I'll venture to say, have always got an idea or two simmering on the back burner — but tend to despair of ever realizing them. Our creative sweat and tears, we feel, are sucked dry in making a living. Our time is gobbled up "on the clock" at work. We embody the modern dichotomy of creative energy at odds with practical demands, and we get ... well, depressed. Working for the buck, we feel we've been coerced into betrayal of our own more creative impulses. Our guilt induces inertia.

But how liberating to think that obligatory distractions, "creative roadblocks," and the scarcity of time may be made to serve and benefit imaginative production — and not prove strictly detrimental as many a creative soul tends to believe.

Back in 1934, the great American thinker John Dewey suggested this very thing. Dewey himself was the rare sort of soul whose scope of achievement seems wholly the product of genius born into an earlier and more salutary age. A preeminent university educator, major philosophical influence on American pedagogy, accomplished psychologist, authoritative social commentator and Humanist spokesman, and highly effective political activist, Dewey also managed to compose some of the most adroit and eloquent writing in the "side area" of aesthetics. It's here, in his great work *Art As Experience,* that he had much to say about the paradoxical

benefits, in creative terms, of a somewhat blocked creative expression.

Where Canin's key term is "restriction," Dewey prefers "resistance," but his gist is much the same: "Resistance accumulates energy. ... The resistance offered to immediate expression of emotion is precisely that which compels it to assume rhythmic form." In other words, it is resistance to its production that makes good art good (the rarity of unadulterated inspiration notwithstanding).

> Since the artist cares in a peculiar way for the phase of experience in which union is achieved, he does not shun moments of resistance and tension. He rather cultivates them, not for their own sake but because of their potentialities, bringing to living consciousness an experience that is unified and total. ... The moment of passage from disturbance into harmony is that of intensest life.

Pushing through resistance, our ideas get toned up, driven to evolve into something better, more creative, and more robust, somewhat in the way a body grows immune to disease by low-level exposure. The ideas' final execution may altogether outshine our original concepts. What's more, we may find that the whole process of germination, resistance, and achievement has taken us to new personal and creative heights. "Resistance that calls out thought generates curiosity and solicitous care, and, when it is overcome and utilized, eventuates in elation."

Granted, *too much* resistance can prove harmful. Katherine Anne Porter once said, "I have no patience with this dreadful idea that whatever you have in you has to come out, that you can't suppress true talent. People can be destroyed, they can be bent, distorted, and completely crippled." Dewey himself puts it this way: "Mere opposition that completely thwarts, creates opposition and rage." Still, medium-size tension can be a good thing, and if the resistance we face is not *completely* obstructive, and we're allowed to make steady, incremental progress toward our creative ideal, we may ultimately find ourselves arrived at what Dewey calls "a more extensive balance...a more significant life."

Indeed, Dewey sees resistance, and the surmounting of it by the creative soul, as aspects of a simple natural rhythm — the yin and yang of existence — and indispensable to a fulfilling life experience. Too much won too easily rarely satisfies, as many a morality tale has told.

> There is no art without the composure that corresponds to design and composition in the object. But there is also none without resistance, tension, and excitement; otherwise the calm induced is not one of fulfillment.

Dewey invokes Samuel Taylor Coleridge's term, "salutary antagonism," a beautiful phrase we may usefully substitute for the more negative "creative roadblock." And here I'm reminded of a snippet from

Wallace Stegner's novel *Crossing to Safety:* "He said he understood that I was into a second novel. How did that go? I told him: Slow and hard. Good, he said. Hard writing makes easy reading. "

How inspiring, helpful, and certainly reassuring are these outmoded perspectives for anybody frustrated by an abundance of back burner ideas and lack of front burner space to implement them. I imagine that's most of us. It's hard work we do whenever we seek to raise an idea from the dark recesses of germination into the light of day. No matter the freedoms or constraints of our circumstances, such work is *always* hard. Who ever said it was meant to be easy?

— *Poets & Writers,* 2014

SLOW & STEADY, PT. 2:
Working without Working

"When I do my first draft, I shut the lights off and pull a stocking cap over my head and eyes, and I'm typing blind. It's the old paradox that you see by blinding yourself."—Kent Haruf

There's a little quote that's been variously attributed to the likes of W.H. Auden, Saul Bellow, Joan Didion, and E.M. Forster. It goes like this:

> How do I know what I think until I see what I say?

Writers cherish this epigram because it gets to the heart of the creative process. Often we sit down to our work at a loss for ideas. We must face, at such moments, the arduous task of relinquishing control, stepping back in order to accommodate the surprise of whatever comes through — be it an ultimately unusable tangent (these are often important to the process), or an aesthetic bulls-eye (rare, but we live and work for the joy these bring). Whether you're a painter, songwriter, or creative thinker of any kind, your process of creation will be the same in this important respect: it will require surrender to the uncontrollably slow, fabulous percolations of the imagi-nation, memory, mind, soul — or, in more strictly psy-

chological terms, surrender to the untraceable workings of the subconscious.

I muse upon these matters daily. The subconscious is a rascal, but I know I'd be lost if I didn't let it do its rascally thing. I love this passage from Annie Dillard's darkly whimsical volume, *The Writing Life:*

> On plenty of days the writer can write three or four pages, and on plenty of other days he concludes he must throw them away. These truths comfort the anguished. ... Most writers might well stop berating themselves for writing at a normal, slow pace. Octavio Paz cites the example of 'Saint-Rol Roux, who used to hang the inscription, The Poet is Working, from his door while he slept.'

For all of us it's true: we do much of our work while lying asleep — or while standing in the shower, or sitting behind the wheel en route to our day-jobs. Always, little cogs keep silently turning. Some rich mineral water seeps up through the strata to surface as a glimmering idea.

Hemingway famously described his working method as a revving-up of his subconscious. As soon as he heard the engine's purr he stopped working and let it run on its own. So, paradoxically, it was when he left his desk that his real work got started. In *A Moveable Feast* he writes:

I always worked until I had something done, and I always stopped when I knew what was going to happen next. That way I could be sure of going on the next day. ... I learned not to think about anything I was writing from the time I stopped writing until I started again the next day. That way my subconscious would be working on it and at the same time I would be listening to other people and noticing everything, I hoped; learning, I hoped; and I would read so that I would not think about my work and make myself impotent to do it.

One must go to the desk, of course, and regularly; nothing will happen if one doesn't. A regimen, in whatever form, is important because it primes the pump. But just as important is surrendering one's *conscious* efforts, letting the spout at the back of the mind burble free.

The following words of Andre Dubus remind me that *not* thinking about one's work, like Hemingway, can be a discipline as indispensable as going to the desk in the first place:

I gestate: for months, often for years. An idea comes to me from wherever they come, and I write it in a notebook. Sometimes I forget it's there. I don't think about it. By think I mean plan. I try never to think about where a story will go. This is as hard as writing, maybe harder; I spend most of my waking time doing it; it is hard

work, because I want to know what the story will do and how it will end and whether or not I can write it; but I must not know, or I will kill the story by controlling it; I work to surrender.

"Art is long," wrote Henry James. "If we work for ourselves of course we must hurry. If we work for *her* we must often pause." Indeed, one must be patient. One must allow for the slow fruition of thought, image, ideas. Rilke called this "being inactive with confidence." And if we reflect, we see that this practice applies to many aspects of life. Essentially, it's the practice of faith. Surrender, stillness, and trust: all are religious disciplines. T.S. Eliot talks about this religious quality of creativity, and even equates one's creative actions with one's destiny:

> Some men have had a deep conviction of their destiny, and in that conviction have prospered; but when they cease to act as an instrument, and think of themselves as the active source of what they do, their pride is punished by disaster. ... The concept of destiny leaves us with a mystery, but it is a mystery not contrary to reason, for it implies that the world, and the course of human history, have meaning.

Stalled as it may seem at times, our work has a meaning and an order. And is anything more gratifying, more creatively pleasurable, than those brief, sparkling mo-

ments when the order becomes clear? In her 2009 book of essays, *Changing My Mind,* Zadie Smith describes a kind of ecstatic sensitivity to convergences produced by a slow, half-blind creative process. This imaginationally critical juncture she dubs "middle-of-the-novel magical thinking":

> The middle of the novel is a state of mind. Strange things happen in it. Time collapses. You sit down to write at 9 A.M., you blink, the evening news is on and four thousand words are written, more words than you wrote in three long months, a year ago. Something has changed. ... If you go outside, everything — I mean *every-thing* — flows freely into your novel. Someone on the bus says something — it's straight out of your novel. You open the paper — *every single story in the paper is directly relevant to your novel.* If you are fortunate enough to have someone waiting to publish your novel, this is the point at which you phone them in a panic and try to get your publication date brought forward because you cannot believe *how in tune the world is with your unfinished novel right now,* and if it isn't published next Tuesday maybe the moment will pass and you will have to kill yourself.
>
> Magical thinking makes you crazy — and renders everything possible. Incredibly knotty problems of structure now resolve themselves with inspired ease. See that one paragraph? It only

needs to be moved, and the whole chapter falls into place! Why didn't you see that before? You randomly pick up a poetry book off the shelf and the first line you read ends up being your epigraph — it seems to have been written for no other reason.

If we care about what we do, if it is *real* to us, and if we approach it with an appropriate mixture of discipline, patience, and surrender, it will germinate night and day — and cannot fail to blossom and surprise us. Or, to return to my earlier metaphor, let us trust that while we tend to the front burners of life's relentless logistical demands, a back burner is cooking away all the while, perhaps reducing a sauce to gourmet richness. Let us spend the little time we're spared stirring that sauce, rather than stewing in frustration. It just may surprise us what the single, seemingly insignificant act of turning the whisk can yield, if faithfully repeated.

— *Poets & Writers,* 2014

THE LONELY NOVELIST'S
5-POINT PRODUCTIVITY PLAN

1. Wake Up Early (Engage the Process)

I get up every weekday at 6:45 a.m. I make my wife's lunch and see her off to work, then settle into my daily rhythm at the desk, amidst my books and papers.* Now, most people have to rise and shine and be at the workplace by 7:30, 8:00, 9:00 a.m., so this may not seem like news. But I include it because for me, waking up early is about more than the literal act of rising from bed in order to arrive at my desk "on time." It's about consciously putting my day before me, giving myself the time to envision its many possibilities, then easing into all that possibility with a sense of purpose and an awareness of each day as an incremental accomplishment on the way to a larger goal. The *process* is more important than the result; without the former there can be no latter.

* Out of respect to my friends in parenthood, it's worth noting that this essay was written prior to the birth of my son. As such, it reflects a regimen whose liberties are no longer available to me. Still, even with the relentless time-constraints parenthood has brought, I've striven to adapt my routine in order to continue honoring the five points here.

2. Get Dressed & Put On Your Shoes (Establish a Ritual Act)

I never sit down at the desk without first changing out of my pajamas and slippers. For me, this outer preparation facilitates an inner one. I guess you could call it a ritual act. It helps me feel more focused or centered. Somehow it also validates or elevates my sense of the work I'm going to do. I arrive at the desk feeling put together, more equal to the challenge, the seriousness, of what's before me. "Look the part," they say in the business world. Translated: If you seek a high-powered executive job, you'd better arrive at the interview dressed like a high-powered executive. That's one element of my meaning here, sure. But more importantly, I'm talking about establishing some active personal ritual, however simple, by which you prepare yourself, body and mind, for immersion into your work.

3. Use an "Isolation Booth" (Nurture Concentration)

There is no greater danger to productivity than distraction. This is true in many professions. And silence (sometimes soft music) is to the writer what a steady hand is to the surgeon. Concentration and productivity are symbiotic. I believe "multitasking" is merely a benign-sounding synonym for distraction. I'm a big proponent of *monotasking,* and for that very purpose I've set up a detached writing studio in my backyard.

This studio is unprofaned by the telephone or Internet. It's my sacrosanct creative space. All one really needs is a designated area, preferably shut off from everything about, where one may focus exclusively on a particular task.

4. Write Longhand (Go Analog)

The advantages of an analog working method are nearly countless. I usually write my first drafts on paper (I filled nine notebooks while working on my second novel). Word processing programs are invaluable later in the writing process, but early on, the backspace key imperils productivity. I produce far more by opening a notebook than by switching on my laptop. Surrendering to the imperfection of the first draft, I escape writerly paralysis. On paper, there's no "highlight and delete" function, hence no compulsive scrapping of text. Sentences, paragraphs, pages are allowed to accumulate in all their lovely inadequacy. A book takes shape this way, flawed at first, and later sculpted and refined. And I suspect that for all those insufficiencies of the early draft, I am a better writer on paper, because my thoughts move more slowly and my imagining is allowed to deepen in that process. Nuances come to light that I might have missed altogether in the hurried tapping of a keyboard. As a bonus, paper productivity allows me to retain a visible record of all my deletions, in case I should later rethink my first impulses; i.e. 'This sentence didn't work in this particular place, but it will go nicely over there!'

5. Think Progress, Not Completion (Stay in the Rhythm)

Avoid overwhelming yourself with the magnitude of the task before you. Trust your process. Novelist E.L. Doctorow said: "Writing a novel is like driving a car at night. You can see only as far as your headlights, but you can make the whole trip that way."

All one can do is orient oneself to the daily act. By putting one's focus into each moment at hand rather than far out ahead at some hazy eventual destination, one does better and more meaningful work — or, to amend Doctorow's analogy, one avoids crashing the car.

— *Soul Shelter,* 2008

IV.

ALERTNESS

Letter *to* a Fellow Writer
Who "Hit it Big" & Got Worried
About Authenticity

Dear N,

I live by the belief that we artists have got to stick to-
gether, and I admire anybody like yourself who would
devote so many years, paid or not, to the production of
something as invaluable — if unquantifiable and in-
creasingly anachronistic — as a serious literary work.

I have no doubt that your new book is well worth
reading, and well worth the astronomical sum paid for it.
I take no issue with writers being well paid. I'm all for
that! What's troublesome, to you and me both, is the
conventional logic of big publishing we're already
seeing at work here: a logic which holds that to discuss
books in terms of the author's payment is a valid or
worthwhile way to talk about literature. Culture, accord-
ing to such logic, is little more than a byproduct of com-
merce — the better paid the book, the more worthy of
attention.

We object to this. It is success-cult nonsense, long
obtaining in society rags and in those Manhattan cocktail
parties we read about in the *New Yorker*, and it spills
more and more into respected literary discourse and
threatens to become a lingua franca.

"How big was the advance?"

"Seven figures."

"Well! I should read it, shouldn't I?"

"Oh, you will. Like every other reader in the Western Hemisphere."

In reality, as experience has taught you and me well, literature flowers and fructifies under a different sun. Its servants toil alone, usually at the edge of things. Most of the world's deserving works are fated to exist in undeserved obscurity while the authors do wage labor in factories, retail stores, or academe — or simply scrounge for food. You and I both recognize that 99.9 percent of all worthy literary creators live by this truth, a truth existent through the ages.

And you believe as passionately as I do, I know, that young writers — or old, still struggling ones — ought to be championed in their wildly impractical, unlucrative pursuits, even if the dominant discourse is all about cash, film deals, and bestseller lists.

Our art lives nowhere but in the work itself, the words on the page. The art surely does not live in whatever gross sum may be paid for it by the hit-hungry New York publishers.

You know this, and that's why you're worrying. Be comforted that you know it. Knowing it, you'll stay the course.

 Yours,

 —M

DEAR FAMOUS WRITERS SCHOOL

Immersed in a 1969 Fawcett Crest edition of Saul Bellow's *Herzog,* a reader notices that a small, yellowing tri-folded brochure has fluttered into his lap. It purports to offer a personal message from Random House founder Bennett Cerf:

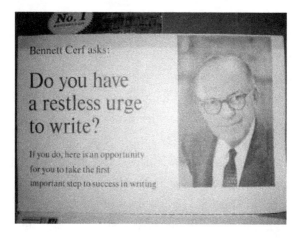

Inside the brochure, the "Famous Writers School" and its "revealing Aptitude Test" are extolled as sure means of harnessing creative inspiration via the guidance of famous literary professionals — and of launching a "successful writing career," finding "success in writing," etc.

Taking a cue from the epistolary impulses of Herzog himself, the reader pens a reply to this transchronological dispatch:

Dear Famous Writers School,
Were you among the first to peddle a secular deliverance from the spiritual pangs of art? Did it start with the likes of you, or could one find your counterpart in the ancient world? You take up, I suppose, an immemorial tradition — the merchant class has always traded in shortcuts, always sold to the confessant a means of circumventing the rigors of real confession: indulgences, &etc. Even Gutenberg perfected his press with funds raised this way. Yes, but with you something is different. What you offered was a new brand of clergy ordained by sales figures and anointed by the pentecostal light of "fame." It was the number of units sold, it was notoriety, it was mass appeal upon which you based your claim of authority. This was sensible, rational. I see your logic. What was lacking, though, was that old dependable leavener: Shame. It only takes a dash of the stuff to increase the nutrients that enable the questioning of questionable undertakings, and thus it's extremely valuable in moderation (in excess, of course, it will stymie all action). I know, the market, perceived to be an autonomous, self-propelling, and amoral organism, has no place for shame. I can see how you got along fine without it, sure. But listen, had you never married the profane and vacuous standards of the dehumanized marketplace to the holy, humanizing

labor of art — or had you never done so in such a
speciously authoritative way and on a such a mass scale
— had you, in short, thought twice before ordaining
yourselves high priests in the New Church of the
Cynical Arts, we might all be better off today.

Maybe.

Yours Truly

‑‑‑‑

A ll signs point toward our desire to institutionalize the artist, to integrate him into the community. By means of university courses which teach the 'technique' of writing, or which arrange for the communication of the spirit from a fully initiated artist to the neophyte, by means of doctoral degrees in creativity, by means of summer schools and conferences, our democratic impulses fulfill themselves and we undertake to prove that art is a profession like another, in which a young man of reasonably good intelligence has a right to succeed. And this undertaking, which is carried out by administrators and by teachers of relatively simple mind, is in reality the response to the theory of more elaborate and refined minds — of intellectuals — who conceive of the artist as the Commissioner of Moral Sanitation, and who demand that he be given his proper statutory salary without delay. I do not hold with the theory that art grows best in hardship. But I become uneasy — especially if I consider the nature of the best of modern art, its demand that it be wrestled with before it consents to bless us — whenever I hear of plans for its early domestication. These plans seem to me an aspect of the modern fear of being cut off from the social group even for a moment, of the modern indignation at the idea of entering the life of the spirit without proper provision having been made for full security.

—LIONEL TRILLING, "The Situation of the American Intellectual at the Present Time" (1952)

John Stuart Mill

WHY IT'S DESIRABLE TO BE ECCENTRIC

In 1859 the great English thinker John Stuart Mill published, in Chapter Three of his treatise *On Liberty,* one of history's most cogent apologias on the subject "Of Individuality as One of the Elements of Well-Being." To Mill's view, mass opinion (what we might call "mass culture" these days), is an undeniable blight to individuality, and therefore directly threatens freedoms civic and intellectual, cultural, and democratic.

While explicitly political, Mill's argument reaches down to the foundations of human nature and culture, articulating many of the challenges we face in a new, media-driven society fixated upon dollars earned, hits per day, and "going viral." As explained by the editors of the Norton Anthology of English Literature:

> *On Liberty* is not a traditional liberal attack against tyrannical kings or dictators; it is an attack against tyrannical majorities. Mill foresaw that in democracies such as the United States, the pressure toward conformity might crush all individualists (intellectual individualists in particular) to the level of what he called a "collective mediocrity."

Herewith, a sampling from *On Liberty,* Chapter Three. Mill, of course, is writing about Victorian England, but at his full-throated best he gives us many a parallel to the mass culture America of today:

> No one's idea of excellence in conduct is that people should do absolutely nothing but copy one another. ...
>
> To conform to custom, merely as custom, does not educate or develop in [a person] any of the qualities which are the distinctive endowment of a human being. The human faculties of perception, judgment, discriminative feeling, mental activity, and even moral preference are exercised only in making a choice. He who does anything because it is the custom makes no choice. He gains no practice either in discerning or in desiring what is best. ...
>
> He who lets the world, or his own portion of it, choose his plan of life for him has no need of any other faculty than the apelike one of imitation. He who chooses his plan for himself employs all his faculties. He must use observation to see, reasoning and judgment to foresee, activity to gather materials for decision, discrimination to decide, and when he has decided, firmness and self-control to hold to his deliberate decision. ...

I like how Mill acknowledges there, in the packed space of a small paragraph, the almost unthinkable difficulty of being a nonconformist: you've got to be *observant*, he says, and *reasonable*, and *judicious*, and *active*, and *discriminating*, and *decisive*, and *firm*, and *self-controlled*, and *deliberate*. As personal characteristics go, that's one tall order. And even then the pressure of the times, preferring mass appeal, is going to oppose you at every step.

But, says Mill, the force of one's inherent character is not to be suppressed, for

> Human nature is not a machine to be built after a model, and set to do exactly the work prescribed for it, but a tree, which requires to grow and develop itself on all sides, according to the tendency of the inward forces which make it a living thing. ...
>
> The danger which threatens human nature is not the excess, but the deficiency, of personal impulses and preferences. ... In our times, from the highest class of society down to the lowest, everyone lives as under the eye of a hostile and dreaded censorship. Not only in what concerns others, but in what concerns only themselves, the individual and the family do not ask themselves — what do I prefer? or, what would suit my character and disposition? or, what would allow the best and highest in me to have fair play, and enable it to grow and thrive? They ask them-

selves, what is suitable to my position? What is usually done by persons of my station and pecuniary circumstances? Or (worse still), what is usually done by persons of a station and circumstances superior to mine?

Such lines of thought became known in modern times as "keeping up with the Joneses." (An idiom which, interestingly, is all but archaic now.)

As for Mill's point about one's tendency to censor oneself, I'm reminded of Ray Bradbury's famously portentous quip: "You don't have to burn books to destroy a culture. Just get people to stop reading them."

Mill continues:

> I do not mean that [individuals] choose what is customary, in preference to what suits their own inclination. It does not occur to them to have any inclination, except for what is customary. Thus the mind itself is bowed to the yoke: even in what people do for pleasure, conformity is the first thing thought of; they like in crowds. ...

Well now, that's putting it bluntly! Yet in light of Mill's make-no-bones perspective, we might challenge ourselves by asking: What are bestseller lists, blockbuster movies, Billboard charts, Oprah endorsements, primetime hits, etc., but symptoms (however benign and excusable) of what Mill calls "the mind bowed to the

yoke"? — that is, things we like because, first of all, *other people have liked them.*

Commerce obtrudes upon culture, and all is fine and well to a degree — until, in Mill's terms, the commercial majority tramples down individual taste.

> They exercise choice only among things commonly done: peculiarity of taste, eccentricity of conduct, are shunned equally with crimes: until by dint of not following their own nature, they have no nature to follow: their human capacities are withered and starved: they become incapable of any strong wishes or native pleasures, and are generally without either opinions or feelings of home growth, or properly their own. Now is this, or is it not, the desirable condition of human nature? ...
>
> Many persons, no doubt, sincerely think that human beings thus cramped and dwarfed are as their Maker designed them to be; just as many have thought that trees are a much finer thing when clipped into pollards, or cut out into figures of animals, than as nature made them. But if it be any part of religion to believe that man was made by a good Being, it is more consistent with that faith to believe that this Being gave all human faculties that they might be cultivated and unfolded, not rooted out and consumed, and that he takes delight in every nearer approach made by his creatures to the ideal conception embod-

ied in them, every increase in any of their capacities of comprehension, of action, or of enjoyment. ...

It is not by wearing down into uniformity all that is individual in themselves, but by cultivating it and calling it forth, within the limits imposed by the rights and interests of others, that human beings become a noble and beautiful object of contemplation; and as the works partake the character of those who do them, by the same process human life also becomes rich, diversified, and animating, furnishing more abundant aliment to high thoughts and elevating feelings, and strengthening the tie which binds every individual to the race, by making the race infinitely better worth belonging to. In proportion to the development of his individuality, each person becomes more valuable to himself, and is therefore capable of being more valuable to others. There is a greater fullness of life about his own existence, and when there is more life in the units there is more in the mass which is composed of them. ...

Let's pause to revisit those two incredible sentences. Each an ode to the value and benefits of idiosyncrasy, each is certainly worth inscribing in memory: 1) "As the works partake the character of those who do them, by the same process human life also becomes rich, diversified, and animating." 2) "In proportion to the develop-

ment of his individuality, each person becomes more valuable to himself, and is therefore capable of being more valuable to others."

> To give any fair play to the nature of [the units and the mass in a culture], it is essential that different persons should be allowed to lead different lives. In proportion as this latitude has been exercised in any age, has that age been noteworthy to posterity. Even despotism does not produce its worst effects, so long as individuality exists under it; and whatever crushes individuality is despotism, by whatever name it may be called, and whether it professes to be enforcing the will of God or the injunctions of men. ...

Can mass culture, then, equate to a form of despotism? We rarely think of the matter in these terms, but Mill, a century and a half before us, was unafraid to do so. And maybe his notion holds today — particularly if we consider the lack of material encouragement and assistance our society offers the arts and humanities.

As John Gardner once put it, "In America, though federal, state, and local governments make feeble gestures of support (the whole National Endowment for the Arts comes to, I think, the cost of one frigate), it seems clear that nobody quite knows what to do with artists."

Mill again:

> There is only too great a tendency in the best

beliefs and practices to degenerate into the mechanical; and unless there were a succession of persons whose ever-recurring originality prevents the grounds of those beliefs and practices from becoming merely traditional, such dead matter would not resist the smallest shock from anything really alive, and there would be no reason why civilization should not die out, as in the Byzantine Empire. Persons of genius, it is true, are, and are always likely to be, a small minority; but in order to have them, it is necessary to preserve the soil in which they grow. Genius can only breathe freely in an atmosphere of freedom.

But today, to take artists for an example, we may repeatedly notice the effects of Mill's "tyrannical majority" where "unpopular," as we use the term, often means more precisely "uncommercial." A book is judged uncommerical by the publisher's sales force, or a movie judged uncommercial ("low concept" as they say) by its production company: These works thereby become predestined to unpopularity.

In a better, more truly pluralistic culture of individuality, a culture in which "peculiarity of taste and eccentricity of conduct" were alive in audience, artist, and marketer alike, being at odds with commerce would not expressly doom a work to unpopularity.

Now Mill gives us three paragraphs meriting invocation in any coherent argument for improved arts funding:

Persons of genius are, ex vi termini ["by force of the term"], more individual than any other people — less capable, consequently, of fitting themselves, without hurtful compression, into any of the small molds which society provides in order to save its members the trouble of forming their own character. If from timidity they consent to be forced into one of these molds, and to let all that part of themselves which cannot expand under the pressure remain unexpanded, society will be little the better for their genius. If they are of a strong character, and break their fetters, they become a mark for the society which has not succeeded in reducing them to commonplace, to point at with solemn warning as 'wild,' 'erratic,' and the like; much as if one should complain of the Niagara River for not flowing smoothly between its banks like a Dutch canal.

I insist thus emphatically on the importance of genius, and the necessity of allowing it to unfold itself freely both in thought and in practice, being well aware that no one will deny the position in theory, but knowing also that almost everyone, in reality, is totally indifferent to it.

… Originality is the one thing which unoriginal minds cannot feel the use of. They cannot see what it is to do for them: how should they? If they could see what it would do for them, it would not be originality. The first service which

originality has to render them is that of opening their eyes: which being once fully done, they would have a chance of being themselves original. …

And now we're brought home to an answer as to why eccentricity is in fact desirable and commendable, no matter how little cash it may earn you:

The initiation of all wise or noble things, comes and must come from individuals; generally at first from some one individual. The honor and glory of the average man is that he is capable of following that initiative; that he can respond internally to wise and noble things, and be led to them with his eyes open. …

When the opinions of masses of merely average men are everywhere become or becoming the dominant power, the counterpoise and corrective to that tendency would be the more and more pronounced individuality of those who stand on the higher eminences of thought. It is in these circumstances most especially that exceptional individuals, instead of being deterred, should be encouraged in acting differently from the mass. … Precisely because the tyranny of opinion is such as to make eccentricity a reproach, it is desirable, in order to break through that tyranny, that people should be eccentric. Eccentricity has always abounded when and

where strength of character has abounded; and the amount of eccentricity in a society has generally been proportioned to the amount of genius, mental vigor, and moral courage which it contained. That so few now dare to be eccentric marks the chief danger of the time. ...

It was men of another stamp than this that made England [read: America] what it has been; and men of another stamp will be needed to prevent its decline.

—*Soul Shelter*, 2009

As artists and professionals it is our obligation to enact our own internal revolution, a private insurrection inside our own skulls. In this uprising we free ourselves from the tyranny of consumer culture. We overthrow the programming of advertising, movies, video games, magazines, TV, and MTV by which we have been hypnotized from the cradle. We unplug ourselves from the grid by recognizing that we will never cure our restlessness by contributing our disposable income to the bottom line of Bullshit, Inc., but only by doing our work.

— STEVEN PRESSFIELD, *The War of Art*

IT IS NATURAL TO NEED HELP

The Lone Wolf Sets Out

In my earlier life a driving passion and some talent for the theater led me to believe I'd pursue a career as an actor, but in the end it was the written component of drama that drew me into literature. Always somewhat ill at ease in the communal, collaborative atmosphere of the thespian world, I found in the more secret art of writing a quietude, concentration, and privacy that appealed to my solitary nature. Here was something you could do (perhaps had to do?) alone.

Writing required no facilities, no stage lights or auditorium seating, no orchestra pits, no janitors to tidy the lavatories. Most importantly, perhaps, it required no return at the box office. String together a few healthy advances and you were set (after all, you weren't aiming for world domination). As a writer you didn't have to fit your life into a rehearsal calendar or the matrix of personalities (outsized egos amongst them) that make up a theatrical cast. Writing required nobody else's presence. The writer could be cast, crew, director, conductor, usher, and janitor — all in one, and all it took was pen and paper, discipline, and yes, self-reliance.

Given those basic tools plus a strong commitment to excellence, it looked like a writer really could "make it" alone and enjoy the gratification of success earned by pure individual merit, as well as the liberty of being one's own man.

I embraced this vision early, and believed that in doing so I was parting ways with the false American Dream, a.k.a.: the rat race. No nine to five or gold watch for me, thank you very much. (Even if I worked full-time to pay the bills — and for periods I did — it would not be my employment that defined me, but my calling as a writer; this I determined early, and so it was.)

A useful vision in its way — it galvanized me to great productivity. Later on, however, even after successfully completing and publishing numerous works, I developed a lurking suspicion that my Lone Wolf outlook might be a bit flawed. Most prominently, it seemed to engender mild but undeniable feelings of humiliation whenever I filled out grant or fellowship applications. And months later, receiving the form letter containing the phrase: "your application was not successful," a strange dejection would dog me for days: *Some Lone Wolf you are. Spurned Puppy is more like it!*

Something was out of joint.

Recently, upon reading Malcolm Gladwell's book *Outliers*, it occurred to me that my early go-it-alone vision was never really a break with the American Dream, but more precisely a variation upon it. That is to say, I had subscribed to the (western capitalist) idea that one succeeds alone.

Thornton Wilder once described American individualism thusly: "The inability to draw strength from any dependency."

I had crept dangerously close to feeling ashamed of myself for seeking, or needing to seek, help.

Success Myths

In *Outliers* Gladwell encourages us to see through our culture's success myths, presenting numerous compelling case studies to help us do so. It seems to me his message is particularly beneficial in any era rife with job loss. "In the autobiographies published every year by the billionaire/entrepreneur/rock star/celebrity," writes Gladwell, "the story line is always the same: our hero is born in modest circumstances and by virtue of his own grit and talent fights his way to greatness. ... [But] people don't rise from nothing. We do owe something to parentage and patronage. The people who stand before kings may look like they did it all by themselves. But in fact they are invariably the beneficiaries of hidden advantages and extraordinary opportunities and cultural legacies that allow them to learn and work hard and make sense of the world in ways others cannot."[*] Later Gladwell goes on, "The lesson here is very simple. But it is striking how often it is overlooked. We are so caught

[*] In his book *Common As Air,* Lewis Hyde makes a related point concerning artistic genius, the development of which, he suggests, always relies upon extensive access to the works of others, a rich and sustaining cultural commons.

in the myths of the best and the brightest and the self-made that we think Outliers [Gladwell's term for the brilliantly successful] spring naturally from the earth."

Meritocracy, or: "Those Who Need Help Do Not Merit It"

America, we are encouraged to believe, is a pure meritocracy. But we do well to remember — especially in tough economic times — that faith in meritocracy is a recipe for unhappiness.

As Alain de Botton eloquently reminds us in his remarkable book *Status Anxiety*: "In a meritocratic world in which well-paid jobs [can] be secured only through native intelligence and ability, money [begins] to look like a sound signifier of character. The rich are not only wealthier, it seem[s]; they might also be plain better."

Botton quotes this creepy sentiment from Andrew Carnegie, written in the latter's 1920 autobiography: "Those worthy of assistance, except in rare cases, seldom require assistance. The really valuable men of the race never do."

Anti-Gladwellian myths have long obtained all around us: that the icons of success did it on their own; that success is won by individual virtue and determination; that to need help is to be unworthy of success.

As these myths persist, the following equation too often applies:

Belief in self-made success + Belief in meritocracy
= Shame, Disillusionment, Despair, or Resignation

The Lone Wolf Was Never Really Alone

Though it's true that the discipline of writing must ultimately be honed and matured in solitude, the sustainment of this endeavor calls for help, be it moral or financial, from beyond the writer's solitary zone. The bracing encouragement of friends and loved ones, the inspiration of teachers or literary luminaries long dead, and indeed, the material assistance of grants and endowments — all are essential to the writer's survival and vitality.

I may give my best, do my all, and still need help. We all need it sometimes. Without the unfailing support and encouragement of my wife it would have been immeasurably more difficult for me to write and publish two novels before I was thirty. This is just the tip of the iceberg of my moral debts.

Likewise, the livelihood that comes of publishing one's work depends upon help from others. Without the continued interest and attention of editors and readers I will not appear in print.

Furthermore, to seek the assistance of grants or fellowships, indispensable as such help would prove to be, needn't cause me shame — even when I am passed over.

I have not done and cannot do it alone. That is, paradoxically, a freeing thought.

— *Soul Shelter*, 2009

Letter *to* an Esteemed Elder Author Concerning Provincialism

Dear O,

Your note in my mailbox was a wonder. I'll keep it close at hand and let it be the talisman that I believe you, in magnanimity, intended.

As the little essay I sent you avers*, when it comes to the question of "writerly" lifestyle, I go in for a deliberate provincialism. Your own remove from mercenary Manhattan, like Updike's early defection to Ipswich, inspires, and I like to claim solidarity with you both on this (and other things, incidentally). Last summer while en route to my first writer's colony residency I passed a night on the Upper West Side where my windowless room and the bustling stony faces on the sidewalks remembered me to myself: from toe to cranium a native Westerner. As for the colony, it gave me hospice and sustenance, and my work roared along — but in the social ways of my talented and genial fellow colonists (predominantly New Yorkers) I was a flunkee. Like a buzzing in my ears there was a constant nettlesome sense of some subtext I was failing to grasp. Coming home to spacious Portland, I was happy to stretch my

* I had mailed Esteemed Elder Author my essay "The Artist as Worker," repurposed in these pages as "Honorable Obscurity: a Primer."

arms, to watch bus drivers smile, and to converse without ulterior themes.

Solitude where I live feels chosen, obscurity a possible boon, while in Brooklyn or the Village these must feel (for the so-called "emerging writer" anyway) like affliction. One's rep in the culture, one's currency in the mags, one's name in the *Times*, one's cred with the editors — all must be practically daily concerns and source of relentless insecurity. Move quickly and be seen, or be trampled. Thanks, but no. Mind be cleansed, say I, and wrestle all ambition downward to the intimate plane of the page and the silent annealing of one sentence at a time.

Still, even this chosen solitude (way out here on the frontier as it is) sometimes feels like chafing isolation and then, against my better instincts, I do dream of the literary day-to-day to be had (or perceived to be had) so easily in New York. All this, of course, is only to tell you how much your wholly unexpected reply meant to me, lending some credence to my dreamt-up solidarity and staving off moral isolation.

You were generous to call my essay superb. I've never been at ease with its conclusion as published: that the non-utility of art best justifies its continuance and practice. Better something along the lines of what Ihab Hassan said (do you know his work?) in the *Georgia Review* a while back: that in this hyperaccelerated age, with its "surfeit of seeming ... art may be the last refuge of our inwardness, our spiritual life: it can never be all surface, it enfolds reality, it confronts even 'the end: ice,

chastity, null' (Thomas Mann)." Oh, but then there is also the case to be made for the value of literature's out-wardness, the reckoning it sometimes brings with the alien and strange. ... But these are all old arguments.

Omitted from my letter was one further thing I'd like to tell you about the good your essays have done me (in addition, that is, to directing me to Trilling's magisterial body of thought and Edel's masterwork[*]). Your insights into the vicissitudes of publishing have, amid a grueling submissions process for my third novel, redoubled my resolve to be uncowed by editors. "Too quiet for this market," reads one major publisher's rejection e-mail, forwarded by my agent (rejectionese, we know, for "not sellable"); then a tiny indie press declines thusly, as if with diametrical comedy: "It's not for us, but we could see it doing well at a more commercial house"; "The voice is very atmospheric and assured," says a third rejecter; "the voice seems needlessly archaic," says a fourth; "I admired the novel's epistolary sections, but..." says a fifth; "I didn't care for the many long letters, which impede the narrative," says a sixth; "Too many themes are crammed in here"; "The themes are not varied enough," and etc., etc. These are actual responses, which for being such a blatant wash are actually — cumulatively — very helpful. The clear message: Do Thy Own Thing. Make, as well as thou knowest how, the book thou hast most wished to make, and stand thee by it.

[*] The five-volume biography *The Life of Henry James* by Leon Edel.

For you, I realize, these have long been applied truths which, coming from another in a letter, must look like platitudes. Yet in putting this down and posting it to O, I pledge it to the stars: none, when this novel's day finally comes, shall cast judgment of much consequence. Finished is the thing, and he who hast made it knows every hair on its head, and none shall tamper but that he shall see reason and justice in the act. Amen.

Yours in continued appreciation,

—M

There's a Crowd on My Desk

Delete Me ...

I killed my Facebook account. It was easy. It felt terrific. Granted, I'd only been a "user" for a few months. My defection was motivated, in no small part, by Facebook's Initial Public Offering, and the corresponding news about Zuckerberg and Co.'s ramped-up analysis and sales of personal data (mine and yours) for its own and others' profit. Such flagrant privacy violations seemed a smidgen too much for this Facebook newbie to stomach. But my main reason for clicking that comical self-vaporization button, "Delete My Profile," had to do with the fact that, being a writer, I'm an inveterate introvert. I get uneasy whenever I consider certain implications of habitual Internet or social media use.

In his 1848 work *Principles of Political Economy*, John Stuart Mill observed:

> It is not good for a man to be kept perforce at all times in the presence of his species. A world from which solitude is extirpated is a very poor ideal. Solitude, in the sense of being often alone, is essential to any depth of meditation or of character ... [and] is the cradle of thoughts and

aspirations which are not only good for the in-
dividual, but which society could ill do without.

Mill's words ring antique today. "The cradle of
thoughts and aspirations" notwithstanding, we can't
simply turn off our cell phones, let e-mails go unan-
swered, or abandon online networking and promotional
efforts, can we? Still, Mill's concept of solitude as an
indispensable, humanizing trait is one that's been reiter-
ated for centuries by the most influential minds of civili-
zation. From back in the 1500s, Montaigne assures us:

> It is not good enough to have gotten away from
> the crowd, it is not enough to move; we must get
> away from the love of crowds that is within us,
> we must sequester ourselves and regain posses-
> sion of ourselves. ... The greatest thing in the
> world is to know how to belong to ourselves.

Thoreau, that sultan of solitude, cautions in his post-
humous 1863 essay "Life Without Principle" that
"When our life ceases to be inward and private, convers-
ation degenerates into mere gossip." He goes on to say,
"I believe that the mind can be permanently profaned by
the habit of attending to trivial things, so that all our
thoughts shall be tinged with triviality." A century and a
half later, his sentiment feels downright contemporary.

It seems to me that these men, all artists themselves,
are talking most directly to the artists among us. Yet in
contrast to such enduring voices, the present cultural

clamoring of social media and Reality TV relentlessly sends two subtle messages. First, being alone amounts to inferiority and embarrassment. Second, being unknown amounts to worthlessness and disgrace. As Dave Eggers observed beautifully in his book *A Heartbreaking Work of Staggering Genius:*

> We've grown up thinking of ourselves in relation to the political-media-entertainment ephemera, in our safe and comfortable homes... how we would fit into this or that band or TV show or movie, and how we would look doing it. [We] are people for whom the idea of anonymity is existentially irrational, indefensible.

You are worthy or desirable, insists the culture of today, inasmuch as you can demonstrate acceptance by others via circuits and cables (or in the case of Reality TV, as long as you can remain a contestant and avoid getting kicked off the show). Similarly, we hear it alleged: you are valid, you are real, inasmuch as you publish evidence daily — even hourly (Twitter, anyone?) — of your existence, your validity.

But there's a paradox here, which is this: even as we crave to abolish isolation and seize proof that we exist, the selves we wish verified may actually become less and less singular or unique, at least in the principle realm we use to verify them, the Internet. Online we are more isolated than ever, but without the soul-shaping benefits of real aloneness. Why log on unless you hope

to connect with somebody, or at any rate *feel connected* to the buzz of the day? Granted, the Web is more than minute-to-minute media, but you get my drift.

Online we live in the thick of one another's quasi selves, what writer Neil Postman called "a neighborhood of strangers." And however manifold are the activities we initiate or the bytes of information we access on the Internet, the medium demands that we stare at a screen, and therefore it cannot enable individuality. To the contrary, as Lee Siegel pointed out in his 2008 book *Against the Machine,* screen-time acts as a force of psycho-physical leveling. To stare at a screen is, for everyone who does it, *the same experience.*

Individuality, personality, and independent thought are conditioned not by the acquisition of information or fiber optic "access" to others, but by varied experience, i.e., away from the terminal. This is a truth at the heart of the imaginative life, and thus at the heart of a creative discipline such as writing. Even as we writers try to keep this in mind, however, we're up against a perplexing frenzy of distractions.

Private Places ...

Aldous Huxley's classic *Brave New World* envisions a blissful and soulless future "paradise" cleansed of societal "ills" such as individuality, books, religion, marital life, and yes, personal solitude — all in the interest of Industry (read: economic superiority), Harmony (read:

societal conformity and obedience), and ceaseless Pleasure (read: distraction).

The Huxleyan future is no authoritarian dystopia, of course. Rather, it's a smoothly functioning society whose citizens, as far as they can imagine, couldn't be happier or more productive. All are prosperous, well fed, pleasantly medicated, entertained, sexually promiscuous (it's the norm, "everybody belongs to everybody else"), and desire nothing other than what's offered to them by their station in the societal hierarchy. The key to their collective health and harmony is the eradication of individual desire through systematic "conditioning" begun at birth. A crucial component of this conditioning is an uninterrupted involvement in communal life, a forbiddance — and inculcated horror of — solitude.

The following bit from the novel describes this culture of mass identity:

> The group was now complete, the solidarity circle perfect and without flaw. Man, woman, man, in a ring of endless alteration round the table. Twelve of them ready to be made one, to be fused, to lose their twelve separate identities in a larger being.

Now, for kicks, let's fiddle with Huxley's wording. Let's put his future citizens around the globe instead of the table. Let's make them many billions instead of twelve. Lastly — ready for this? — let's change "solidarity circle" to Internet.

I've brought us dangerously close to modern heresy, I realize. The Internet as we know it is much more fractious than Huxley's gray-eyed group-think. At its best, articulate debate defines it. But the point remains that we relinquish something quintessentially human — and, for us writers, something integral to the mindful processes of creation — in being constantly logged on, accessible, and vulnerable to the manipulation of our focus and the depletion of our attention spans. "Being online," suggested Sven Birkerts in *The Gutenberg Elegies*, "and having the subjective experience of depth, of existential coherence, are mutually exclusive situations." Meanwhile, the work of selfhood — the cultivation of personal, psychic, and spiritual independence which can yield brilliant and idiosyncratic artistic breakthroughs — will remain, as ever, inescapably tied to solitude and its concomitants: privacy, slowness, inner quietude, and anonymity.

In a 1968 interview in *The Paris Review*, John Updike alluded to the locales that tended to foster his best writing: "A few places are specially conducive to inspiration — automobiles, church — private places." It was an offhand remark, not unique for its time. But in our present cultural context does it not sound practically eccentric? *Private* places? Today, we give over more and more of our waking hours to a realm that is not and never can be private. As we all know, the Internet engenders connection addiction, a constant transplanting of the self from its real, palpable world into the virtual hive life and its maze of information stimuli. While online, I

get addled, jittery, ill at ease in my own skin. The undesirable effects are much like those of strong pharmaceuticals. I've discussed the issue with friends, and there tends to be a consensus — in face-to-face conversation anyway, and increasingly in the greater cultural dialogue. Jonathan Franzen reportedly relies on a special Internet avoidance technique while working: he disables his computer's wireless signal and seals its Ethernet port.

"We are driven," wrote Neil Postman in *Technopoly,* "to fill our lives with the quest to 'access' information. For what purpose or with what limitations, it is not for us to ask; and we are not accustomed to asking, since the problem is unprecedented." Postman was writing in the early 90s. Today, in our Web 2.0 age, one can easily imagine Postman suggesting that our latest technologies drive us to deplete our own personal, psychic, and spiritual independence.

Meanwhile, by contrast to our ever worsening jones for constant technological communion, we may still reflect that a primary benefit of being solitary is that it facilitates *being*, that natural state of the soul in which you find yourself "in the moment," as they say. Right here, right now. And art-making — perhaps most obviously the art of writing — is all about being in the moment. Montaigne pioneered the personal essay while sequestered in a gothic tower. Thoreau's unclassifiable work of genius, *Walden*, resulted from a two-year stint alone in the woods (which was itself simply a supplement to his lifelong habit of solitary country rambles).

Like the generations before us, we modern mortals need to be reset on a regular basis, reconditioned to the natural, non-mechanical pace of the world and of our own creative souls. As Updike states, and as Franzen's Internet deprivation tendency would suggest, privacy and solitude facilitate inspiration.

Predisposed as we are to move our thoughts, our inner lives, our reading habits further online — and thus further into the public technological sphere — it is only healthy to pause and consider: where goes our sense of self, our ability to be alone, think alone, believe alone? Where goes our propensity for discipline and self-reliance, for creating a thing solely because we believe, down to our human core, in the thing's intrinsic value — even if it should never be seen by anybody else and thus never elicit praise, profit, or prestige.

Intentional Solitude ...

On the rear flap of an old edition of J.D. Salinger's novel *Franny & Zooey* I recently discovered the following impish testament, penned by the novelist himself, and well worth framing above one's desk:

> It is my rather subversive opinion that a writer's feelings of anonymity-obscurity are the second-most valuable property on loan to him during his working years.

Today we may ask: what if Salinger's proverbial writer faces a perpetually compromised anonymity, a lack of solitude precluding the blessings (yes, blessings) of obscurity? Say the young writer is — if not famous in the traditional way — then "socially famous" on Facebook; say he's got 962 "friends" whose irresistible avatars dispel his focus hourly; say he's engaged by thirty-seven e-mails daily; or say, instead of recording his thoughts and imaginings in the privacy of a paperbound journal, he blogs these things to the world and then spends his days patrolling reader comments?

Interaction is apt to become the *raison d'être* of our time. We rate our technologies first by the efficiency with which they allow us to reach another person and gather data. And quick, even instant measurability of that efficiency is a chief advantage of online media. Send an e-mail, get a response. Build a Web Site, then tabulate "unique visitors" and hits per day. Set up a Facebook page, count your friends. Despite certain pragmatic advantages afforded by these tools, they are ultimately a bane to writers, for within such a hypersocial, data-driven ethos, it appears to follow that endeavors failing to serve the ultimate utilities — i.e., connection and measurability — call for abandonment. How, if steeped in social media culture, can one still conceive of spending three to seven years writing a novel in the quiet of one's study?*

* Writer Dalton Conley, in his book *Elsewhere, U.S.A.,* coins a term for a new breed of person incubated in the age of wireless connectivity: the "Intravidual."

In a 2011 *Harper's* interview, Zadie Smith confessed, "When I am using the Internet, I am addicted. I'm not able to concentrate on anything else. ... I use Freedom [the Internet-blocking software program], I put my phone in another part of the house, it's pathetic. Like a drug addict. I put it in a cupboard so that I can write for five hours." Smith is not alone. The Freedom software website boasts praise from the likes of Dave Eggers, Nick Hornby, Nora Ephron, and Miranda July. "The gods are just," wrote Shakespeare in *King Lear,* "and of our pleasant vices make instruments to plague us." (Huxley was so fond of the line he included it in *Brave New World.*)

The Internet, TV, and mass media in general promise to save us from ourselves. Solitude is now completely avoidable. But how does such avoidance impoverish us writers and artists — our creative process, our craft, our productivity? We know very well the benefits of social media — and yes, these have their place. But what are the costs? What do we lose when we trade in our anonymity?

"We are not merely social beings," says William Deresiewicz in a 2009 article in *The Chronicle of Higher Education* entitled "The End of Solitude,"

> We are each also separate, each solitary, each alone in our own room, each miraculously our unique selves and mysteriously enclosed in that selfhood. To remember this, to hold oneself apart from society, is to begin to think one's

way beyond it. ... No real excellence, personal or social, artistic, philosophical, scientific, or moral, can arise without solitude.

The spirit of the age notwithstanding, we may possess in our solitude, our anonymity, our inwardness and interiority, the precious resources that have produced and sustained the best and most enduring cultural creations of the ages. No matter how popularly devalued these resources grow to be, no matter what suspicion or scorn each may come to arouse, we ought to hold them dear — we artists most of all.

— *Fiction Writers Review,* 2012

V.

A BRIEF
AUTOBIOGRAPHY

LEARNED BEHAVIORS :
NOTES ON NARRATIVE & BELONGING

Creeds ...

We were noble, forgiving, self-sacrificing. We were messengers riding out front and sometimes, historically, were killed for the news we brought. We were martyrs, marchers, confessants, confessors, a conservative avant-garde. And every year, we staged a crucifixion.

Marked ...

A weird mix of privilege and oppression colored my grammar school years, the blessing and burden of being fingered out as special. At first it was the anointing looks my elders gave, later I felt it inside. They all said I'd grow up to preach. Even my birth story, as my parents told it, took this tack: the doctor's swat, my deafening howl, and from behind the white mask the diagnosis: "We've got a preacher!" (likely a standard delivery room quip, yet in my case how helpful an augury it seemed). Later on, a pious youngster, I had no reason to chafe as grownups all around me invoked this destiny constantly. Their presumption, to my eyes, was discernment in the Apostolic sense ("To one is given through

the Spirit the utterance of wisdom ... to another the discernment of spirits."). Yes, some Lord-crafted lodestone lay at the seat of my soul — a tugging fate. I was, as Saul Bellow's Charlie Citrine describes himself in *Humboldt's Gift,* "stamped and posted and they were waiting for me to be delivered at an important address." Evangelical Wunderkind: how could I object? To be a preacher — especially to be *meant* to be one — was to know your business on earth, to be the guy who got it straight. Sanctification, veneration, a smidgen of fame? Yes, please — all leavened, of course, with Edenic humility: we were, one and all, punted from Paradise long ago and let none forget it.

So I owned my youthful calling, embodying it gladly as I then knew how. By heart, as early as second grade, I had memorized great chunks of the *New International Version*, chapter and verse. We Cunninghams attended service thrice weekly, and glued to a pew for each of these hour-plus sermons I'd often pluck the small yellow tithing cards from the pew box and, in fields reserved for designating the month's monetary pledge or submitting prayer requests, would scratch down abbreviated exegeses of the pastor's message, dropping these into the deep velvet bag that came around during the offertory:

Our faith should be fragrant to people around us, like the oil the woman uses to wash Jesus' feet.

Zaccheus climbing the tree to see Jesus reminds us that we should rise above our sinful world in our love of the Lord.

Fundamentalist evangelicalism is not without its pseudo-literary pretensions, and a regard for these. That I stagnated in the banal substratum of the children's Sunday School (a pedagogy of felt boards and popsicle-stick crucifixes), that I moved up early to the ostensibly more sophisticated climes of Youth Group, was widely known. To my peers in Sunday School through all my churchgoing years, I was the go-to man for Biblical reference, commentary, and interpretation.

Weekdays at my public school I behaved as this church reputation demanded, frequently broadcasting my faith in overwrought testimony to friends, or insufferable commentary on their un-Christ-like behavior, less frequently in extra credit reports on the life of Jesus, evidence of the End Times in current events (material cribbed from *The 700 Club*), or the latest archeological efforts to pinpoint the final dry dock of Noah's Ark. I scrutinized all my teachers (was Mrs. Natenkemper a Christian?). At every opportunity I dragged a friend to church. Most significantly, every time my sinful nature got the better of me (that is, daily), I condemned myself. Each instance of lying or lust, each "curse word" or mere taint of doubt in the font of faith would bring out my own private cat-o'-nine-tails. Suitably bloodied, in thrall to the horrors of hellfire, and believing that when the rapture came I was to be deservedly *left behind* (as

the latterly bestselling evangelical thrillers have put it), I prostrated myself before God, awaiting his forgiveness — and fearing his wrath.

Pageantry ...

Even more than the frankincense and manger straw of Christmas, I loved our Easter musical. At the production's heart was a long, shockingly explicit crucifixion scene. This scene always featured our Youth Pastor, a thirty-something amateur bodybuilder whose biceps could hardly have been circumscribed by my belt at the time, and whom I loved as I could love no other hero.

Call him Sid. Garbed in the short white skirt of a Roman soldier, capped by a gold-painted plastic helmet complete with earguards and red-bristled centurion mohawk, Sid, heading up a corps of soldiers, lumbered down the aisle of our spot lit gymnasium-turned-theater lashing a short whip across the back of a staggering, cross-bearing Jesus (an absurdly Anglo churchgoer named Keith). "Move it!" *Lash! Lash!*

Off in a side row I sat, a frightened juvenile baring my orthodonture at the melodrama. I had a *passion* for that Passion Play — whose horrors, I'm sure, scarred the psyche of many a kid younger than I.

I recall something not vaguely sexual stirring in my boyish limbs during this scene. And for weeks following Easter I would replay the high pornographic drama of Keith's/Christ's bloodstained stagger toward Golgotha, recreating the scene with colored felt tips in the privacy

of my bedroom: Christ hunkered under the splintery cross with red globules oozing down face and spine, as though the day rained blood. Some years the play's carnage was thicker than others — depending, I guess, on the varying pathos of the backstage makeup people. What I see now is a veritable Jackson Pollock of gore from Keith's shoulder blades to the waistline of his diaper-like loincloth. And there in the blinding spotlight behind him is Sid. "Move it!" *Lash!*

Heroics ...

Sid's magnetism generated from those massive biceps and pecs, fortified regularly with half-cups of powdered amino acids and cheek-reddening bench-presses. He was, as my older brother liked to say, "ripped." Early every Tuesday before school, I and a few church peers would meet Sid at a local Denny's for Bible study. Afterward he would drop me at my junior high. What an enviable sight I felt on those mornings, climbing down out of Sid's sparkling Bronco. "Dude," I imagined schoolmates murmuring (particularly the tougher boys who shoved me around now and then), "is that his dad? That guy's ripped!" Unlike the pop stars and pro athletes serving as objects of hero worship for those kids, Sid was immediate and real.

He was also a walking aggregation of adolescent preoccupations, a fact which had repeatedly landed him in hot water with parents at church. Numerous mothers (mine no exception) scowled at their kids' reports of

Sid's pranks, which included leading his Christian charges on midnight campaigns toilet papering Pastor Kellogg's house, staging public spectacles like the "dollar dive" at the local mall (wherein a dollar, planted in plain sight, was rescued with a sliding body dive across the polished floor a second before a hapless shopper could bend to pick it up), or tormenting the boys of Youth Group with top floor "snuggies" (better known as "wedgies").

I found these hijinks inspired, and though I walked then in mortal dread of the snuggie, I still give Sid points for originality. He had, I remember, a fetish for horror movies, and even screened *Night of the Living Dead* for us during a church all-nighter, only to leap up — in a different kind of horror — during the nude grave dancing and orgy scene, chuckling as he scrambled to stop the tape, "Whoa, okaaay, time for a different movie." How refreshingly distinct he was, blunders and all, from the bland — and on occasion excoriating — moralism operative in our congregation. Sid liked fart jokes. He drove fast. He enjoyed a plug of Kodiak or Copenhagen.

Prankster or not, however, Sid was no maverick when it came to theological mores — creed-wise he was as conservative as my mother, and could dish out moral spankings and Biblical shamings like the best of his elders. Still, he was the first nonconformist adult I ever knew. Lively renegade and irrefutable man's man, he made my kind of Christianity — its prayer groups and Bible flashcards — inarguably cool. I was ineluctably drawn to him, intoxicated by him. I wanted *to be* Sid.

115

Storytelling ...

Saint Augustine, in his *Confessions,* tells the fascinating story of his conversion. Lingering in the courtyard of his mother's house one day, he heard a disembodied child's voice imploring him to take up the scriptures and read. Obeying, his eyes fell upon some lines of Saint Paul and immediately, "it was as though the light of confidence flooded into my heart." He dashed inside to tell his mother he'd been saved.

Reading this account today, I realize that all conversion experiences have an essential commonality: one is seized by the sense of one's own crucial position inside a story — one's life clicks into place as a facet in a much larger tale, where the world's salvation hangs in consequence. A moment of profound transformation arrives and one is, for a glorious or gloriously humiliating instant, placed unmistakably center stage. Implicitly, Augustine's hot flash of "confidence" at the moment of conversion is an awakening to, a confidence in, *narrative* — the authentic, life changing power of story.

The evangelical emphasis upon personal Testimony — and I can't say how many testimonies, stirring and convulsive, I heard in church — exemplifies the enduring importance of stories and storytelling to a spiritual life, and to the life of the church in which I grew up. "And from that moment forward I renounced my old ways," etc. "I became part of The Story."

To belong, it turns out, always means *to belong within a narrative.*

Iconography ...

Having executed my detailed crucifixion drawings, I
would carefully destroy them. What would my mother
have thought to find them? Or would the weird inter-
mingling of evangelical zeal and proto-sexual perversion
have occurred to her? It was a kind of highly protestant
self-pollution, enacted in the locked sacrarium of my
bedroom, followed by a quick disposal of evidence —
but maybe Mom would not have punished me as she
would were she to find me in the grips of a pornography
purely secular.

In retrospect I think I was suffering some psycholog-
ical mix up, a sort of erotic transference relating to my
idolatry of Sid and his casting as Christ-torturer. Invol-
untarily I became a Christ-torturer myself. That I felt no
keen guilt — only momentary pangs — seems strange to
me now. At the time, I guess, it was all in the spirit of
the Pageant. (And was I so different from, say, those
icon painters of seventeenth century northern Europe,
whose dying Christs resemble horrid dinner delicacies
cooked rare?)

The elaborateness of our Easter Pageant might sur-
prise anyone unfamiliar with the fundamentalist Christ-
ian style, but I've only nicked the iceberg. Earlier in the
play Jesus rode up the aisle astride a live donkey, hailed
by an uproarious Jerusalem of smiling children by the
hundredfold, each waving a palm branch. Utterly inno-
cent of liturgical foundations or efficacious ritual, the
evangelical spirit is nonetheless obsessed with the theat-

rically ornate. It wants spiritual pyrotechnics, gratuitous public confession, ticklishly unnerving reports of things apocalyptic or Satanic. It wants tearful testimonies of the once demon-possessed; the soft-spoken come-clean of a former pedophile; the open repentance of a *saved* homosexual (one unforgettable Sunday night in seventh grade, I witnessed this last).

Were we hateful? No, not outright. Prurient? Sure, if inadvertently. Clueless? Yes, in our way. Bigoted too — though never militant, never even particularly aggressive. Beyond casting the always conservative vote, campaigning on the matter of prayer in school, and being staunchly "pro-life," we were basically apolitical (the amped-up lust for public office of the Christian Right over the last twelve or thirteen years still surprises me). Naturally, we didn't see ourselves as fundamentalist; most of us were happily "non-denominational," floating from Baptist to Methodist to Nazarene. We went wherever the Spirit was felt.

Absence ...

To write of these things now is tricky, a bit like trying to extract from an old photograph the substance of a much younger self, to snap figure from background in order to prop it up in three dimensions — "There, *gotcha!*" But for all the self-violence, sanctimony, and other vinegary psychology of those formative years, they amount, almost despite themselves, to something more meaningful than mindfuck. I now disown the institution of the

church entirely, and yet when I'm honest I recognize that never in later life have I felt so warm, deep, and validating a sense of inclusion within a community, a total involvement, an enveloping familial *belongingness.*

My ultimate defection from "The Story," and thus from its belongingness, became a crucial contour in the narrative of my life — the absent communal warmth defines me as much as did its presence. I grew up to be a writer. If I now live outside "The Story," it's for the sake of stories in general, my own life being but one among many. "Never again," goes John Berger's celebrated passage from his novel *G.*, "will a single story be told as though it were the only one."

I can never go back to that particular narrative, alluringly warm in memory but frightfully narrow in truth, because I belong, in a sense, to all stories — or anyway, some involuntary force has dedicated me to the ideal of such belonging. John Keats meant something similar, didn't he, in calling the poet "the most unpoetical of anything in existence; because he has no identity — he is continually in for — and filling some other Body."

Iconoclasm ...

Sid self-destructed. His disapproving elders may have seen this coming from miles away, but it was the horror of my youth. One Saturday we learned he'd been arrested at home by — preposterous! — FBI agents on charges of Grand Theft. He was suspected of stealing binders full of vintage baseball cards from a shop run by a kid in

Youth Group. Oh pathos! Oh betrayal! Sid admitted guilt right away. He was arraigned and carted to prison within days. Pastor Kellogg brought in counselors for us distraught kids in Youth Group. I remember the counselors' chart delineating the stages of grief. It seems to me, even now, an apt approach to our trauma. This was the first grievous loss of my life.

Before the close of my seventh grade year some months later, we heard that Sid, released on bail, had promptly robbed a women's clothing store in broad daylight, telling the clerk there was a man outside with a gun. Back to jail it was.

I understood then that I'd never see him again.

Reverse Augustine ...

Early on I hurried, seeing the light, hurdling to rise. There was so much to learn, to internalize, to testify, so much sinfulness to shed, only for this dogmatism to be abandoned and mostly forgotten. There's no pocketing enlightenment. It gets lost in the wash or goes the way of pennies and pens down the back of the couch. The guys at the Quickie Lube find it dried to a crust under the driver's seat. Or maybe that's putting it too cynically. I'm more of a mind with T.S. Eliot: "There is only the fight to recover what has been lost / And found and lost again and again."

In the shock wave of Sid's sudden absence, I experienced the harsh clarity of an examined life. Well-meaning adults, some of them Sid's erstwhile detractors,

filled his place in Youth Group. How could they be anything but pale, lifeless, hypocritical? It was as if I suddenly stood outside looking in, seeing what I and those around me had always glaringly been, what I'd never realized we were, what I could never fully be again. This state of helpless criticism brought me zero intellectual pleasure (not for nothing does the word *criticism* derive from *crisis*). I was tearing away, experiencing the agony of having my narrative, the only one I'd ever known, cauterized.

Compared to the belongingness of my upbringing, my "churchless" life — two decades now — looks like pure post-modern alienation. In many respects it *has* been an outsider's existence, marked frequently by the disturbed sense of an atomized modern life, of adults adrift in a proximity everywhere only vaguely defined (neighbor, co-worker, merchant/customer), of mere politeness and civility — and yes, occasional anomie — underlying a pandemic of spiritual isolation.

We like to believe in the "autonomous self existing independently, entirely outside any tradition and community," suggest the authors of the seminal cultural study *Habits of the Heart: Individualism and Commitment in American Life* (1985). But they go on to note that the self as tabula rasa is a "powerful cultural fiction." The soul, always formed by community, needs community in whatever form, needs in some way to belong.

But I also agree with James Baldwin where he writes, "Art is here to prove, and to help one bear, the

fact that all safety is an illusion. In this sense, all artists are divorced from and even necessarily opposed to any system whatever." The artist, whom the work of imagination renders at once honoree and outcast, is everywhere and nowhere at home — and that in itself is belongingness of kinds.

From the Biblical gospel of my youth I would graduate, eventually, to the gospel of American transcendentalism as penned by Thoreau and Emerson, then on into wider literary/aesthetic realms. My devotion today is the muddled life of the creative mind, complete with chronic ambivalence, allergies to dogma, and those inchwise flights of elation won at the price of weeks — more often months, still more often *years* — of thematic, syntactical, and lexical agony. I've always held that embracing my literary yen was the more wholly authentic means of living up to my cosmically postage-paid sense of self, that prior I'd been mistaken if not misled in my felt destiny of preacher-to-be, and that all the time I was headed for an unavoidable appointment with my own self development, my inevitable awakening id. To a degree, all that is true. Yet while I do find the life of writer most suitable for me — even "fated" — how much do I owe to that profound, incalculably formative touch of consecration bestowed by the church, back in the years when I first came to know what a "calling" felt like?

And what do I owe to Sid? To what deep degree did his rebel tendencies provide me a taste of an entirely different, free-thinking life? Maybe Thoreau and Emerson clicked perfectly into the niche Sid first carved.

My early belonging, though I renounced it, formed me in some incontrovertible way — formed me even by virtue of renunciation. For all the delusions and agonies, I cannot unweave that piece of my history from the whole. "The Story" shaped how I see the world.

I'm grateful.

—*Fiction Writers Review,* 2013

VI.

JE EST UN AUTRE

SEX, DEATH, & ART-MAKING AS LIVING
(on Paul Zweig's *Departures*)

In 1956, twenty-one-year-old American Paul Zweig began a temporary life in the Latin Quarter of Paris. "This place, overloaded with time," bore no resemblance to his native city, New York. Long a setting considered inordinately conducive to the task of living passionately, Paris, for Zweig, would also be a death-draped maze: womb to the grim realism and poetic fever dreams of Rilke, Rimbaud, Zola, and Baudelaire. But the city embraced the young Zweig with its promise of a real, uprooted life — a counterpoint in every way to the bland, unhappy spiritual orphanhood of his early youth in the Jewish environs of New York's Brighton Beach. Paris's sexy aliveness and layered deathiness amounted to an enlightened and consoling *otherness.*

He stayed a decade. "It was precarious and exalting to be nowhere, almost to be no one," he wrote of these years in his memoir *Departures.* The book is an ode to otherness.

Departures remained unfinished upon Zweig's death from lymphoma in 1984 (at age forty-nine), a fact I found surprising on my first reading years ago. Rereading it today, I'm still surprised; the book has a structural seamlessness, a completeness of vision that suggests inspiration fulfilled, and this owes to something far more

integral than the fact of Zweig's death, an externality whose mauve shadow inevitably plays over the pages.

Assembled by editors from finished chapters, partial chapters, and notes, *Departures* first appeared in 1986, though it was doomed to drift out of print for a quarter century. In a way, I didn't believe it when I learned Other Press would resurrect these memoirs. I'd formed one of those arcane, despairing attachments a reader sometimes does. Deprived of fellow devotees, unable to suck up the nutrients of conversation as a book lover must, I'd taken *Departures* into a kind of hermitage: reader/*inamorato* and overlooked opus, scornfully alone together. Thankfully, this magical book may now radiate its enhancing phosphorescence into other readers' lives.

Departures concerns Zweig's sexual history, social displacement, and brief Communist activism during his decade in Paris. A third and final section centers on his late days back in New York, reckoning with his terminal illness. As Adam Gopnick notes in a new introduction, Zweig fused in this book the three discrete themes of popular memoir as we've come to know that genre: expatriation, recovery, and religious alteration. Which is to say that *Departures* is about the ways in which a self can be surrendered, recreated, and resurrendered.

One night, at around age nine or ten, remembers Zweig,

> I got out of bed and went down to the basement.
> The cement floor was covered with a layer of
> coal dust that was soft and fine to my naked feet.
> The furnace loomed in a corner, cold and black;

it was summer. I took my pajamas off, and felt the cool night air all over my body. My penis rose like a small, thin bone, and the darkness wheeled about me slowly, peacefully, and a wild contentment ran down my legs. After a few minutes, I put my pajamas back on, and went to bed. Such were my moments of true living: cosmic, blank, almost impersonal.

Earlier, Zweig remembers a similarly weird moment, this one from his mid-twenties in Europe, on a scorched peak in the Spanish Pyrenees:

An altar stood on the mountaintop, dominated by a stone cross. I took my clothes off, lay down on the altar and dreamed of Arlette [Zweig's first Parisian lover]. As I lay there half asleep, my nakedness became immense. The little breezes were fingers sliding over my body. Without completely waking up, I masturbated. The sacrilege was thick and real, and I felt cowed by it. God wouldn't have to look very far to punish me. I was waving my penis in His face. I was exposed to the heavens on that block of mountain limestone. I giggled nervously in the enormous silence, happy with the beads of sweat dripping from my stomach, and the harsh wincing light.

Both passages are representative of Zweig's candor and mystery, and of a book that's as much a song of ap-

petites as it is a nocturne haunted by notions of spiritual and mortal expatriation. Zweig, a self-described Wandering Jew remembering wild enchantments in Paris's slant-walled garrets and cracked-plaster courtyards — and striving to relate the much-too-vivid taste of his own mortality in a Manhattan apartment twenty-four flights up — enshrines all the while the human embrace (never possessive, never grasping) of everything vital yet irredeemably liquescent in a life. Not the clutch but the *reach* is consecrated in *Departures* (what do we ever really clutch?). *Empty, Distant, Secret, Fantasy, Ghost* — these, along with *Slippage*, are among the book's keywords.

In the first pages, Zweig's lithe but unknowable lover, Claire, gains sexual climax in a "helpless," "grateful," amazed, releasing, Galatean "gulp." To come, for Clare, is to become — she nurtures the ultimate appetite; her body "took in, took in endlessly." But Zweig can feel her "disappearing in my arms," even in the ecstasy. Her mouth, "unhinged and gaping," becomes a void. He can't reach her, can't attain the "interchange of selves" he seeks. The message at this early stage (here he's thirty-one) is this: beyond one's own immense solitude, one has only the encounter — a moment, a glimpse, a sometimes cool, sometimes hot collision of self and other tinged with incipient leave-taking. As *Departures* here suggests and will ultimately avow, lurking over all intimacies is, of course, the final leave-taking.

From that Holocaust haunted moment of boyhood in an ashy, unspoken of basement where the sinister fur-

nace looms, to Zweig's celestial/sexual hunger atop the mountain, spurting at the heavens in an act that's all at once despairing, mocking, and insanely hopeful, *Departures* explores its themes of self-making and human relationships — one person to another and each to his own mortal coil — in the dialectic of sex and its cold and anxious opposite, solitary death.

While he's uniquely articulate — at times transcendentally so — Zweig, like anyone charting this territory, owes something to Updike. Who can forget the bedroom moments in *Rabbit, Run*: Harry Angstrom receiving the woman's look of sad forgiveness, "as if she knows that at the moment of release, the root of love, he betrayed her by feeling despair. Nature leads you up like a mother and as soon as she gets her little price leaves you with nothing."

Sex in *Departures* — and there's plenty — is the taut emblem of all vitality, not just the male biological kind. The taut penis is life's bowsprit, the limp one "a laughable tombstone, a bit of nameless flesh, sticking out of some grass." Unnerved upon witnessing a few untimely deaths, Zweig suffers a case of temporary impotence in Paris. His lover tries to help him, and Zweig is frank about the importance of her gesture: "She wasn't offering me only sex, she was offering me life." A Hindu friend once told him, "I'm not material," meaning the guy couldn't get it up. To be impotent is to disappear. To make love is to gain purchase, as Lionel Trilling said, on "the moment of life in the infinitude of not-being."

"Around the age of five or six," Zweig later writes, "my friends vanished, and I was alone. It seemed to happen all at once." In Brighton Beach he became a boy for whom "friendlessness was mysteriously rich. ... I learned how to be alone even when there were people around." And he carried through life this awareness of space and distance as latent capacities in all human relationships. Together, alive in "the forlorn exchanges of substance that weld us to others," we make love against loss; alone in the "bundle of vacated rooms and amazing basements known as memory," we live against death; meanwhile we're carried inexorably toward both. These are Zweig's stern but not necessarily despairing truths, and *Departures* is not a despairing book.

If memoir lately sways toward summational self-edification ("Here's what I learned about me") or salubrious self-categorization ("How I became what I am") or proffers readerly takeaways ("You can learn from my life!"), *Departures* blows open the self, trafficking in memories always mysterious, never definitive. Zweig's self-portrait shows a human soul hungry for an infinitude of lives, for a chameleon existence unconstrained by geography, culture, upbringing, language, or political fidelity. Zweig fascinates as he describes his crazed plot to master French through reading, at an agonizing snail's pace, the whole of French literature: "Words became substances. ... Week by week, I constructed a new past for myself... gave myself a new mouth, a new walk, new eyes. The books were doing it." And then he rivals himself with an account of his brief

involvement in the French Communist underground aiding dissident Algerians: "Politics was a language for the shucking of myself." At every point the gist is the same: indeterminacy — searchings and confusions included — is for him at the heart of identity. Envisioning the self, Zweig envisions not enclosure but bewildering space. Here there are no lineaments, only persistent, restless opacities, and the luminous, heartbreaking, life-affirming, delectable reach!

> In truth, we are not ourselves — je est un autre, Rimbaud had written — but a yelping tender chorus, a 'barbaric yawp.' Each of us is a crowd strolling out into a chaotic, lovely, slightly dangerous neighborhood: a throng of faces, oversized and shifting, recreated by love, by fascination.

Even Ralph Waldo Emerson, with uncharacteristic mournfulness, notes: "Souls never touch their objects. An innavigable sea washes with silent waves between us and the things we aim at and converse with. ... All our blows glance, all our hits are accidents." Obliquity, wandering, departure — these are human inheritance. But that we live facing death needn't mean living less, just as to make love facing loss needn't mean loving less. If there's a moral in *Departures*, it's this. However, as Gopnick nicely puts it in his introduction to the new edition, "Good writers give us their moments, not their morals; they dramatize their moments as morals."

Departures, ill-fated book of an ill-fated man, refers us beautifully outward on every living page, outward toward the (Zweigian keyword) *substance* of the world, of another. This is true even of the pages where Zweig considers the horrible paradox of being a writer while dying.

Here my own thoughts swerve in irresistible parenthetical to an impulse of my three year old son, who almost daily runs crying into my arms after a fall, impatient to describe the conditions and events leading up to his hurt. He wants to make of pain — if not sense or meaning — then narrative. To create, to augment through narrative's reach, the possibility of understanding: that's instinctually enough. Telling stories somehow saves us, though injuries don't smart less or heal faster, though we remain as perishable as ever, and forever in peril. Zweig locates and sacramentalizes, with words any serious writer ought to take to heart, the doomed (also blessed), self-preserving (also selfless), instinctual reach of the artist:

> I felt an incongruous need to finish the book I was working on. Did the world need another book? I knew that wasn't the question. ... [Writing] was the cohered tensions of living made deliberate and clear. Writing, I touched the roots of my life, as I did when Vikki and I made love, or when I spent an afternoon with my daughter. ... And this crabbed hieroglyphic, curling from top to bottom of the page, was my mind climb-

ing quietly and privately to a plane of spirit that
balanced above my sick body. ... A work is not
a life, but writing is living.

— *Tin House,* 2011

She was trying to get straight in her head the connection between ambition and love. She meant ambition for herself and love of her work. They were often in opposition, ambition degrading love. The reverse was also true, but much less harmful.

— WARD JUST, "In Search of the Next Idea"

VII.

DEFENSIVENESS

Elohim Creating Adam
William Blake, 1795/circa 1805

BRAVELY UNCONVENTIONAL IN 1799

In the summer of 1799 the English mystic, poet, and painter William Blake sat down to pen a lively document in defense of the imagination, the inventively eccentric, in sum: the artistic spirit. For anybody laboring in service to a dream, an image, or voice of inspiration, whose work defies convention or leaves folks wagging their heads in disapproval or bewilderment, this text is a prime comfort.

Blake was addressing a dissatisfied client. Reverend John Trusler had commissioned from him some illustrations, but upon receipt found them to be stylistically disagreeable — and, one guesses, too drastic a departure from traditional Christian iconography. Blake specialized in the unorthodox but evidently what Trusler whiffed most clearly in the artist's flair was "immorality."

> August 23, 1799.
> Revd. Sir,
> I really am sorry that you are fall'n out with the Spiritual World, especially if I should have to answer for it. I feel very sorry that your ideas & mine on moral painting differ so much as to have made you angry with my method of study. If I

am wrong, I am wrong in good company. I had
hoped your plan comprehended all species of
this Art, & especially that you would not regret
that species which gives existence to every
other; namely, Visions of Eternity. You say that
I want somebody to elucidate my ideas. But you
ought to know that what is grand is necessarily
obscure to weak men. That which can be made
explicit to the idiot is not worth my care. The
wisest of the ancients consider'd what is not too
explicit as the fittest for instruction, because it
rouses the faculties to act. I name Moses, Solo-
mon, Aesop, Homer, Plato.

Given Blake's uninhibited defense of his own work
— an act justifiably recognized in some as blind egotism
— it's worth bearing in mind that he had by this point in
his career attained a stage of technical mastery. For all
his eccentricities, his self-confidence (righteous indigna-
tion?) was just. In other words, it was not self-import-
ance, delusional pride, or base implacability that
prompted his letter, but something far more profound.
Blake knew well — and said elsewhere himself — that
"Without unceasing practice nothing can be done. Prac-
tice is Art. If you leave off you are lost." And he knew
the intensity and dedication with which he practiced.
Because Blake was consummate he could be honestly
unconventional, and rise to his own defense without
unduly flattering himself regarding his gifts. There's an

important difference between faith in one's unique vision and fallacious pride.

> … But as you have favor'd me with your remarks on my design, permit me in return to defend it. … I perceive that your eye is perverted by caricature prints, which ought not to abound so much as they do. Fun I love, but too much fun is of all things the most loathsome. Mirth is better than fun, & happiness is better than mirth. I feel that a man may be happy in this world. And I know that this world is a world of Imagination & Vision. I see everything I paint in this world, but everybody does not see alike. To the eyes of a miser, a Guinea is far more beautiful than the sun, & a bag worn with the use of money has more beautiful proportions than a vine filled with grapes. The tree which moves some to joy is in the eyes of others only a green thing which stands in the way. Some see Nature all ridicule & deformity, and by these I shall not regulate my proportions; & some scarce see Nature at all. But to the eyes of the Man of Imagination, Nature is Imagination itself. As a man is, so he sees. As the eye is formed, such are its powers. You certainly mistake, when you say that the Visions of Fancy are not to be found in this world. To me this world is all one continued Vision of Fancy or Imagination, & I feel flattered when I am told so. What is it sets Homer, Virgil, & Milton in so

high a rank of Art? Why is the Bible more enter-
taining and instructive than any other book? Is it
not because they are addressed to the Imagina-
tion, which is spiritual sensation, and but medi-
ately to the Understanding or Reason? Such is
true painting, and such was alone valued by the
Greeks & the best modern artists. ...

Blake's religious regard for the Imagination (capital
I) reminds me of some remarks by his contemporary
John Keats, written in a different letter some years after:

I am certain of nothing but the holiness of the
heart's affections and the truth of Imagination.
What the Imagination seizes as beauty must be
Truth, whether it existed before or not.

What was it Blake said at the outset? "If I am wrong,
I'm wrong in good company."

I am happy to find a great majority of fellow
mortals who can elucidate my Visions, & part-
icularly they have been elucidated by children,
who have taken a greater delight in contemplat-
ing my pictures than I even hoped. Neither youth
nor childhood is folly or incapacity. Some child-
ren are fools & so are some old men. But there is
a vast majority on the side of Imagination or
spiritual sensation.

To engrave after another painter is infinitely more laborious than to engrave one's own inventions. And of the size you require my price has been thirty Guineas, & I cannot afford to do it for less. ...

I am, Revd. Sir, your very obedient servant,

William Blake

There it is: the stout and soundly articulated refusal to compromise or let one's art be co-opted for fear of missing out on a buck. And time has proved the rightness of Blake's refusal. His work is still very much with us. Who over the last several generations has not read or memorized in school those haunting lines,

> Tyger! Tyger! burning bright
> In the forests of the night,
> What immortal hand or eye
> Could frame thy fearful symmetry?

As for the good Reverend Trusler? We're told he was the author of two books: *Hogarth Moralized* and *The Way to be Rich and Respectable*. Says it all, I fear.

"[Blake] was a commercial artist who was a genius in poetry, painting, and religion," says Alfred Kazin, editor of *The Portable Blake*.

He was a libertarian obsessed with God; a mystic who reversed the mystical pattern, for he sought man as the end of his search. He was a Christian who hated the churches; a revolutionary who abhorred the materialism of the radicals. He was a drudge, sometimes living on a dollar a week, who called himself 'a mental prince'; and was one.

Yes, Blake knew what he was about, knew *how* to go about it, and didn't let anything divert his vision — certainly not a crabby critic. Note, by the way, that little biographical tidbit about living on a dollar a week. Blake was poor. Good art has never guaranteed good income, much as being guided by one's own lights rarely does. Therein we find a caution for the faint of heart. But also, perhaps, comfort for artists unpaid but as yet undaunted.

Stay the course. Blake and brethren have got your back.

— *Soul Shelter*, 2008

IN DEFENSE *of* RELIANT NOVELS

This essay originally appeared as a post on my author blog, Spring 2008.

On the Critical Mass literary blog, one of the current PEN/Faulkner Award judges, Molly Giles, offers a glimpse of her experience sorting through the boxes and boxes of books by prospective awardees. Her observations are interesting, and strike me as much more well considered and humane than the run of the mill cynicism of other lit judge reflections regularly showcased in the realm of literary gossip (which often feature comments along the lines of: "I got so sick of reading I started looking for reasons to quit a book; if a novel used first-person present tense I immediately threw it aside and reached for the next.").

Literary judging is, fundamentally, an elite privilege. It therefore carries with it a kind of moral responsibility. Ostensibly, a judge is commissioned to prize great literature, wherever it is found, and seek its furtherance. Thus the judge ought to take pains to ensure that his or her range of consideration is as broad and inclusive as possible. In other words, merely reviewing the latest Roth, DeLillo or Updike — or lavishing the better part of one's attention upon titles already widely embraced or

copiously reviewed while merely skimming work by an unknown — does nothing for the cause of furthering this country's contemporary literature. Then again, perhaps an award can never suffice for that.

But Giles certainly deserves applause for breaking the mold with her affirmative and uplifting perspective, as revealed in statements like: "Few of the titles I loved were publicly visible." And while it's often impossible to know, as a novelist, just how fully ignored or engaged one's work may be by readers, let alone by award judges, I found it heartening to note, near the close of her comments, that my book *Lost Son* did receive consideration (see her embedded reference to a novel she read — or at least looked at — about Rilke). "Month after month I did nothing but read," Giles reports,

> I hunkered down, hooded over. Finally, the last box was emptied. A bare space glimmered on my dining room table. … I had twenty-six pages of single spaced notes, a new trifocal prescription, a deep respect for my two fellow judges, who had been sweet-tempered and supportive, and I'd been in the company of some of the most wonderful writers in America.
>
> What did I learn?
>
> That most of what gets published deserves to get published.
>
> That most of what deserves to get published also deserves to be showcased in bookstores,

airports, and book clubs — and is not. Few of the titles I loved were publicly visible. ...

That American writers prefer the past to the present: the bulk of the novels I read were historical fictions, many of them based on real people. While I enjoyed reading about Woody Guthrie, Florence Nightengale, Errol Flynn, Rilke, Hitler, Byron, Pocahontas, Stephen Crane, Edward Curtis and William Blake, among others, I wondered why ... why rely on the known instead of the invented? Some novels even recycled fictional characters: Huck Finn's father, Gregor Samsa. My conclusion: it's easier for novelists because this way they know the end.

"Huck Finn's father" refers to Jon Clinch's impressive novel, *Finn*. And the Gregor Samsa reference, I believe, is to the wonderful *Anxious Pleasures* by Lance Olsen. "Errol Flynn" denotes Margaret Cezair Thompson's *The Pirate's Daughter* (with which my book shares a colophon). "Pocahontas" signifies Matthew Sharpe's surreal *Jamestown*.

While Ms. Giles' reflections as an erstwhile judge deserve praise for thoughtfulness, I'm chilled by the dismissiveness of her final remarks, the nonchalant disrespect they exhibit. If we want to ponder why novelists write novels based on real people or preexisting fictional characters (a subject well worth discussing), we should not allow an essential question to elude us in favor of

one that is implicitly ungenerous. Most certainly the question should *not* be, as Giles puts it: "Why rely on the known instead of the invented?" Phrased this way, the prompt itself contains a pre-emptively qualitative judgment, implying not so subtly that the writers of these works look for ("rely on") shortcuts, and find them in the existent narratives of another person's biography or another writer's plotline instead of writing ("inventing") something of their own. Given a question so erroneous, it's no wonder Giles offers so crass an answer: "It's easier for novelists because this way they know the end."

It's easier. Now, there's a sentiment unbefitting the largesse Giles has already demonstrated. Why insinuate authorial laziness, rather than grant that some more honorable artistic impulse may motivate such novelists?

To be fair, Giles is not writing a critical essay here. Her tone is offhand. Maybe she thought her cursory estimation would best serve her closing — and coming from a novelist would supply a dash of wryness. But she ought to remember that she's writing as a judge, and her observations will be read as those of an arbiter of literary quality.

Were Giles to examine at length the matter she briefly raises, I should hope she would reach a more worthy conclusion — and that her colleagues in award committees and critical circles would do likewise. First, of course, they would need to revise the question. And a more responsible question would be: "Why return to these known stories?"

I pose that question to myself now, wanting to grant it the thought it deserves. As one who has novelized the life of Rilke, I could give my own extensive answer — but I've already done so elsewhere.[*] Rather than repeat myself, I want to turn to E.L. Doctorow, a gifted novelist with a long career of "relying on the known" in such novels as *Ragtime, Billy Bathgate,* and most recently *The March,* the 2006 winner of ... well, the PEN/ Faulkner Award.

In a marvelous essay for the 2006 Fiction Issue of *The Atlantic*, "Notes on the History of Fiction," Doctorow makes numerous cogent observations on the very subject which, when briefly raised by Ms. Giles, evokes only her condescension. Doctorow's piece is worth quoting at length, but I'll start with three sentences:

> Common to all the great nineteenth-century practitioners of narrative art is a belief in the staying power of fiction as a legitimate system of knowledge. While the writer of fiction, of whatever form, may be seen as an arrogant transgressor, a genre-blurring immoralist given to border raids and territorial occupations, he is no more than a conservator of the ancient system of organizing and storing knowledge we call the story. A Bronze-Ager at heart, he lives by the total discourse that antedates the special vocabularies of modern intelligence.

[*] See "Rainer Maria Rilke: Myths, Masks, and the Literature of a Life" at http://mallencunningham.blogspot.com.

Ms. Giles, I fear, would disagree. Her disparaging remarks suggest a critical inclination to divorce modern fiction entirely from what Doctorow calls "the total discourse."

In fact, whether Giles is being tongue-in-cheek or not, I feel she evinces an apparent fallacy in contemporary literary perception. It's precisely because this fallacy finds voice in such an obviously thoughtful person that I can't help but wonder just how insidious, how little observed, the shallow idea might be even in those disseminating it. Giles' casualness in letting it slip leads me to suspect that it's a notion of some currency — one getting passed around like a pathogen. Its hosts may hardly notice it, though they're transmitting it wherever they go.* The fallacy, of course, is this: the novelist who employs the age old device of *retelling,* who looks to "the known," who dares to rummage in history, biography, or indeed literature itself, is inevitably a kind of cheat, a lesser talent, one too lily-livered to make up his own damn story. The only truly worthy novels of today are those that rely exclusively on authorial invention, those in which the author does not already "know the

* This does seem to be the case. To take one example from the literary mainstream, historical novels have been consistently disparaged by critic James Wood: "I dislike most historical novels: science fiction facing backwards." (*New Yorker*, June 28, 2010); "Historical novels [are] a somewhat gimcrack genre not exactly jammed with greatness." (*New Yorker*, May 7, 2012)

ending." Historical, biographical, or lit-spinoff novels, on the other hand, reflect little more than the novelist's cheap "reliance" upon events or imaginations not his own.

The sophism is clear enough if we follow the embedded logic, which insists that history, biography, and literature are inflexible and exhausted — that they cannot possibly accommodate imagination or invention. Indeed, Giles absurdly indicates that the ending of any reliant novel can only mimic the "known" ending of the story that forms its basis — never mind whether the reliant novel prefers intimate characterization over historical explanation, like Karen Fisher's magnificent PEN/ Faulkner finalist *A Sudden Country,* whether it delights in the inventively askew as does Olsen's *Anxious Pleasures,* or proves merely obliquely referential to its historical basis, like Ondaatje's *The English Patient.*

My Rilke novel, I must protest, does not end with the poet's death. Though the novel begins from the "known" record of Rilke's life — and his death will indeed remain the conclusion of that ever expanding record — *my* narrative of Rilke operates by methods of inquiry distinct unto itself, therein becoming its own uniquely inflected record, and thus naturally culminating in a unique conclusion.

Every fictional narrative, whether or not emergent from an actual history or preexisting story, will lay down its own laws. In order to be sustained by the author and absorbed by the reader *as literature,* it will demand invention at every turn. The reliant novelist's work there-

fore, if not harder than the "inventor" novelist's, is most certainly no "easier."

I've described *Lost Son* as a letter sent to a ghost, which is my way of highlighting the very personal nature of the novel, for the book does not purport to be — and is not interested in being — an authoritative portrait of Rilke, a known story retold. The creation of fiction based on the life of a poet as legendary as Rilke can only be a personal process, and that personal process — the important process of seeking to understand, assimilate, and perhaps transcend one's influences — is as much the theme of my narrative as are the events of Rilke's life. Thus, *Lost Son* opens with an epigraph by author and critic Lee Siegel:

> We must understand one another or die. And we will never understand one another if we cannot understand the famous dead, those fragments of the past who sit half buried and gesturing to us on memory's contested shores.

Lost Son, being personal and subjective, being the record of one individual *search for understanding,* is a new story.

Ms. Giles, apparently, is an academic. Is her fallacy university born? (Surely it doesn't come of her role as an author.) I admit that I share Thoreau's innate mistrust of institutions ("Wherever there is a lull in truth," said old Henry, "an institution springs up"), so I suffer an involuntary wariness toward academe where it professes to

nourish and sustain literary art through drills in technique, the doctrinal enshrinement of certain great texts, or consensus opinions in workshops — pedagogical approaches that risk breeding what Frank Lloyd Wright called the incubus of habit that besets the mind. Wallace Stegner (a creative writing teacher himself) was referring to this very incubus when he spoke of where critics go wrong:

> They tend to run in pack. ... For ten years at a time a single critical attitude rules, and a limited range of books is praised, a special vocabulary springs up, bright graduate students catch the tone and lingo and write (and here is a case of writing with an eye very definitely on an audience) to please the reigning critics rather than to discuss a new book in its own proper terms. ... Being so pluralist a nation, we ought to have pluralist literature and pluralist literary criticism. The fact is that nothing in so much as our literary criticism do the forces of fashion and stereotype take over.

Elsewhere, Stegner was equally perceptive and outspoken regarding the kind of learning universities ought to foster:

> What we most need is neither generalists nor specialists, but specialists who can generalize and generalists with a specialty. ... Try self-

consciously to produce specialists and leaders in
[a] pre-professional college, and you will, I am
convinced, produce half-men, limited men, men
with imperfect vision and low horizons.

I can't help feeling that Giles' bizarre notion ought to
elicit a bold question. We know our universities are fast
becoming the last bastions of learned literary apprecia-
tion in this country, as good review publications dwindle
to ever smaller numbers and independent bookstores
fold in the shadows of corporations. In the absence of
any substantial system of literary patronage, universities
are among the last incubators, even, of new literature;
while BookScan figures bar the development of healthy
young novelistic careers, witness how many of our
nation's wonderful literary journals are produced under
the auspices of institutions. And given this state of af-
fairs, this cocooning away of literature, further separ-
ating the art of fiction from "the total discourse" and
moving it toward classification as a discrete (even
arcane) discipline, we must ask ourselves how many
unexamined critical biases are incidentally produced?
Do MFA programs, given their dynamic of a collective
criticism, unwittingly (I emphasize *unwittingly*) prop-
agate such biases? Could an idea like the one at hand —
that historical novels are not real novels — ever emerge
spontaneously and in isolation? Or mustn't some vector,
perhaps many vectors, such as those in the social/literary
culture of an institution, be responsible? Who can say?

Not I, certainly. I won't pretend to draw conclusions here. I only wonder.

In the end, of course, such questions are diversions from the more material concerns: 1) That we recognize this particular bias to be an emperor lacking clothes, and 2) that we examine an emphatically current artistic impulse as it deserves to be examined, in a conscientious, responsible, and respectful manner. If American writers today "prefer the past to the present" we ought to allow for the possibility, at least, that a certain artistic merit, and maybe even artistic significance, underlies this tendency. Better that than to leap to the disheartening conclusion that novelists today shun invention and scramble after the easy and well known.

I only bring up universities because Doctorow's eloquent apologia continues with an insightful observation about them — or about their essential irrelevance to the novelist (Doctorow has taught at NYU):

> [The] gift of the [novelist's] practice seems to come of its inherently solitary nature. A writer has no credential except as it is self-awarded. Despite our university graduate programs in writing there is nothing that licenses a writer to write, no equivalent of a medical degree, or a law degree or a Ph.D. in molecular biology or divinity. Writers are on their own. They are specialists in nothing. They are liberated. They can use the discoveries of science, the poetics of theology. They can ventriloquize as anthropolo-

gists, report as journalists; they can confess, philosophize, they can leer as pornographers, or become as wide-eyed as children. They are free to use legends, myths, dreams, hallucinations, and the mutterings of poor mad people in the street. All of it counts, every vocabulary, every kind of data is grist for the mill. Nothing is excluded, certainly not history. …

The writer has a responsibility, whether as solemn interpreter or satirist, to make a composition that serves a revealed truth. … The novelist hopes to lie his way to a greater truth than is possible with factual reportage. The novel is an aesthetic rendering that would portray a public figure interpretively no less than the portrait on an easel. … That the public figure of historical consequence makes a fiction of himself long before the novelist gets to him is almost beside the point.

Once the novel is written, the rendering made, the historical presence is doubled. There is the person and there is the portrait. They are not the same, nor can they be.

And here we find supported with glorious authority a truth I noted earlier about the novel as an art form. The novelist's portrait, if it is a serious work, is *an entity in itself,* raising concerns wholly unique to the sensibility from which it emerges, and plumbing depths not yet plumbed in any such manner by the historical or biog-

raphical records that precede it. Put another way, the narrative of a historical, biographical, or lit-spinoff novel moves along an arc no less autonomous or artistically absolute than that of any other good novel. That this arc is rooted under a larger factual arc does not alone make it a mere narrative excrescence — nor a simple plagiarism of the past. If it is truly a novel, it throws its own parabola, whether it involves so-called known figures and events or not. If it is truly a novel, its locus lies wholly within itself.

What's more, we might further consider the nature of the "known" upon which the novelist in question "relies." Surely history, biography, and enduring literature are far more personal, and therefore perpetually subject to interpretation, than Ms. Giles allows by her concluding slur ("easy endings"). Where is the authoritative account of the American Civil War to assure us we know that story once and for all? — and I mean no disrespect to the massive achievements of Shelby Foote. Where is the conclusive life of Thomas Jefferson or John Brown, Marie Antoinette or Albrecht Dürer? Where the inarguable commentary on Kafka's *The Metamorphosis*? A billion radii can be drawn to these everlasting centers of human thought, event, and persona — which is the very reason we revisit them our whole lives long. In fact, we tend to find them, after the passing of years, accentuated with meaning entirely new to us. Surely Ms. Giles, being an author herself, cannot believe these enduring narratives to be as static as she inadvertently propounds. And she must agree that the

novel, that most prismatic of art forms, by its excursive and complicating points of view, by its use of the endlessly lithe and subjective medium of language, by its prodigal narrative descants, its soul-scouring close-ups and chronological curlicues and go-anywhere frames of vision — surely the novel is uniquely suited to present us with two (or two hundred) fresh explorations of an event or a person we thought we "knew."

The successful historical, biographical, or lit-spinoff novel can function as something far richer than a faithful reiteration. It can remind us powerfully of the ambiguity reigning over our impersonal history just as it reigns over our ostensibly personalized present. It can remind us that the realms of the human, being inexhaustibly various, are ultimately unknowable, and therefore a source of neverending mystery and discovery, vast spheres for neverending excursions. A reliant novel might well reawaken us to the hollowness of dogma, the flatness of much inherited understanding, and the human responsibility to gaze long at our own predecessors, our own defining events — to judge them if we must, but to do so by virtue of a humanizing complexity and a non-trivializing empathy.

In my case I find my novel's main character, Rilke, subjected to a speciously "defining" force exerted upon him by the generations who try to understand his work. He must weather the curse of all legendary figures: turned into a spokesman for a certain way of life or a certain artistic manner. Coerced into this posthumous mouthpiece role, he gets a violently polarized reputation.

He's either adored as a saint of modern poetry, or re-
viled as a profligate husband and father. But conducting
my own novelistic inquiry into Rilke's story, I know that
neither of these two extremes can truthfully reflect this
bygone figure. And meanwhile, I seek to create a work
that illumines and affects. I wish to stir in readers a reso-
nant equivalent of what Rilke's story stirs in me. That
task can only be undertaken in a manner deeply person-
al, humane, and probably more self-revealing than
Rilke-revealing. And so the resulting novel, I believe, is
something much more storied, much more necessarily
inventive than a known tale retold.

Doctorow continues with a further salient point:

> The scholarly historian and the undocumented
> novelist make common cause as operatives of
> the Enlightenment. They are confronted with
> faux history as it is construed by power, as it is
> perverted for political purposes, as it is ham-
> mered into serviceable myth by those who take
> advantage of its plasticity.

One might amend this comment to note that the bio-
graphical novelist, too, is often confronted with faux
biography as it is construed by hagiographers, icono-
clasts, cynics, or old associates or cousins nursing a
grudge. But, says Doctorow,

> The novelist is alone in understanding that

reality is amenable to any construction placed upon it.

The historian and novelist both work to deconstruct the aggregate fictions of their societies. The scholarship of the historian does this incrementally, the novelist more abruptly, from his unforgivable (but exciting) transgressions, as he writes his way in and around and under the historian's work, animating it with the words that turn into the flesh and blood of living, feeling people.

The reliant novel, by taking us back to those old imaginative centers in its expeditions of invention, inquiry, and enrichment, is nothing less than a reconnaissance mission of the human spirit back into itself.

So, why create a novel that revisits a "known" story? Sven Birkerts, in his brief essay, "Biography and the Dissolving Self" (1994), may provide one answer with regard at least to biographical fiction. His is a cultural interpretation which insightfully considers our Zeitgeist of "fragmentation," "abstraction," and endless bureaucracy:

> More and more we find ourselves living at a remove, with the feeling that life has gone blurry, has lost its singular intensity; we feel our coherence dissipating among needs, obligations, and great troves of competing stimuli...[but] burrowing into a life, the reader experiences clarity and purpose by proxy. It is an exalting

baptism. For one thing, the circumstances of earlier times were, if not simpler, then more resonant, and felt more authentic. ... Things seemed to have density, weight — to matter. ... Biographical narration itself is premised on coherence and meaning. The biographer almost occupationally views his subject as living under the aspect of a singular destiny, with everything around him contributing to press his experience into its intended shape. Which of us feel some comparable sense of destination about our premillennial lives?

Why start a novel from a "known" story? I have my own intuitions, which tell me authors do so — and will continue to do so — because such work may serve to bind human beings to one another across time, battle lines, and social divides. Because such work may help us by its arresting humanity to become more expansive, imaginative spirits, to traverse and restore even those realms that were formerly but great black spaces where inspiration had stagnated or empathy withered.

. . .

Each of the following reliant novels offers the reader far more than a known story retold or an all too familiar

ending recycled. Each will reward your attention abun-
dantly:

-*Lydia Cassatt Reading the Morning Paper* by Harriet
Scott Chessman (about Mary Cassatt and her sister)
-*The March* by E.L. Doctorow (about General W.T.
Sherman's infamous march)
-*Insect Dreams* by Marc Estrin (another remarkable
work about Kafka's Gregor Samsa)
-*A Sudden Country* by Karen Fisher (about the Oregon
Trail)
-*I Should Be Extremely Happy in Your Company* (about
Lewis & Clark) and *Fall of Frost* (about Robert Frost)
by Brian Hall
-*The Assassination of Jesse James by the Coward Robert
Ford* by Ron Hansen
-*Wintering* by Kate Moses (about Sylvia Plath)
-*Raising Holy Hell* by Bruce Olds (about John Brown)
-*Coming Through Slaughter* by Michael Ondaatje (about
jazz legend Buddy Bolden)
-*The Master* by Colm Toibin (about Henry James)

...

Quotations used in this piece: "Notes on the History of
Fiction" by E.L. Doctorow, *The Atlantic* 2006 Fiction
Issue; *On Teaching and Writing Fiction* by Wallace
Stegner, Penguin Books 2002; *The Selected Letters of
Wallace Stegner* edited by Page Stegner, Shoemaker &
Hoard 2007 (letter to David Packard, May 1959);
Readings by Sven Birkerts, Graywolf Press 1999.

How Reading Keeps Us Safe

The following remarks were delivered at the annual ACLU Uncensored Celebration in honor of Banned Books Week, Portland, Oregon, September 2009.

When we celebrate books, or rise to defend them, even in a gathering like this one, what we're really celebrating, what we really defend, is the survival and wellbeing of the Individual (capital *I*). I think that's important to remember. A book comes alive only in the single, solitary consciousness of an individual. It begins its life in the consciousness of the writer, and finds its apotheosis in the consciousness of the reader.

In Ray Bradbury's *Fahrenheit 451*, the book burner Montag says in a moment of illumination:

> Last night I thought about all the kerosene I've used in the past ten years. And I thought about the books. And for the first time I realized that a man was behind each one of the books. A man had to think them up. A man had to take a long time to put them down on paper. ... It took some man a lifetime maybe to put some of his thoughts down, looking around at the world and

life, and then I come along in two minutes and boom! it's all over.

A book cannot exist without an individual to write it, and it cannot really come alive or make its meaning or do its work or become memorable until an individual takes it down off the shelf, opens it, falls quiet, and reads.

So when we protect books against censorship we protect the expressive Individual as creator and as receiver. We protect the writer or reader whose thoughts, feelings, or imaginings may stand at odds to a status quo. We protect what is idiosyncratic, nonconformist, visionary, or even eccentric, and see that it remains a possibility in the cultural dialogue. We not only say yes to Walt Whitman's *Leaves of Grass*, but we open our arms to the new Whitman of today. We do all this in the belief — not only that books should be vehicles of free expression — but that readers thrive among us, that the individual still wishes to take a book down off the shelf, open it, fall quiet, and read.

But the truth is that quieting down and reading is getting harder and harder. David Ulin wrote about it in the *L.A. Times* in August 2009:

> Sometime late last year...I noticed I was having trouble sitting down to read. ... It isn't a failure of desire so much as one of will. Or not will, exactly, but focus: the ability to still my mind long enough to inhabit someone else's world,

and to let that someone else inhabit mine. ...
After spending hours reading e-mails and field-
ing phone calls in the office, tracking stories
across countless websites, I find it difficult to
quiet down. I pick up a book and read a para-
graph; then my mind wanders and I check my
e-mail...

And Nicholas Carr wrote about it in *The Atlantic* in
2008.

Immersing myself in a book or a lengthy article
used to be easy. ... I'd spend hours strolling
through long stretches of prose. That's rarely the
case anymore. Now my concentration often
starts to drift after two or three pages. I get fid-
gety, lose the thread, begin looking for some-
thing else to do. ... The deep reading that used to
come naturally has become a struggle.

I think I know what's going on. For more than
a decade now, I've been spending a lot of time
online.[*]

Many of us, even the writers among us, know exactly
the feelings Ulin and Carr describe. And we've seen lots
of similar articles and editorials in the last few years.

[*] Carr's article "Is Google Making Us Stoopid?" was
subsequently expanded into the excellent book *The Shallows:
What the Internet Is Doing to Our Brains*, W.W. Norton 2010.

It's hard to sit still. It's hard to focus. And this raises questions: If even the readers among us struggle to attend to the printed page, what does that mean for books? What does it mean for the survival and wellbeing of the Individual? What does it mean for censorship?

Censorship and banned books result, of course, from a social force that seeks to smother the individual, the idiosyncratic, the nonconformist. Censorship is an aspect of Group-Think. This is old news. (Back in the mid-1800s John Stuart Mill referred to this Group-Think as the "tyrannical majority." And in his novel *1984*, George Orwell calls it "Orthodoxy.") Because it's a social org-anism, Group-Think will always be with us in one form or another. So it's a matter of making sure it doesn't get in the way of individual thought.

Books can endanger Group-Think because, as Jonathan Franzen has said, they can teach us to be alone. Group-Think sees a threat in too many people learning to be alone. "You can't consume much if you sit still and read books," says somebody in Aldous Huxley's novel *Brave New World*, a famous banned book published in 1932.

Group-Think wants us cruising the aisles under fluor-escent lights buying things, or sitting at home inside our digitalized TVs, or stuck in traffic subjected to FM advertisements engineered to keep us thinking about the next thing to buy. Group-Think would prefer that you never power off, never log off or leave the chatroom or silence your cell phone or turn off your video game for

the sake of quieting down and learning to be alone with a book.

Years after *Brave New World*, Huxley warned us about "the development of a vast mass communications industry, concerned in the main neither with the true nor the false, but with...the more or less totally irrelevant." Mankind, said Huxley, has an "almost infinite appetite for distractions." Reality TV anyone? (And I say this as somebody who once had a full season obsession with America's Next Top Model.)

Writing about television, Neil Postman took up Huxley's theme. He pointed out that in the new "information age" distraction is as much a threat to culture as censorship, because being always distracted becomes a way of censoring ourselves. He said:

> Those who run television do not limit our access to information but in fact widen it. But what we watch is...information packaged as entertainment. Tyrants of all varieties have always known about the value of providing the masses with amusements as a means of pacifying discontent. But most of them could not have even hoped for a situation in which the masses would ignore that which does not amuse.[*]

Can books amuse? Absolutely, if you can manage to quiet down and read them. But don't you dare skip out

[*] *Amusing Ourselves to Death: Public Discourse in the Age of Show Business* by Neil Postman (1984)

on primetime in order to test that assertion. Group-Think wants you tuned in—always fixating on the latest news snippet, fixating on So-and-so's slap-down of So-and-so, fixating on Tyra's next Top Model Pick (count me guilty), fixating on PlayStation — and always social-izing, text-messaging, e-mailing, Facebooking, Twit-tering.

We draft our own cultural death certificate, and pos-sibly the death certificate of America itself when we consent to the suppression of a book. But we draft that same tragic document when we involve ourselves in the distractions of mass culture to an extent where we end up basically ignoring books — when we give up the special habits of self-cultivation and deep consciousness that books offer us: how to be alone, how to be quiet, how to focus, and how to engage another consciousness at length — whether to cherish its views or reject them.

If we allow censorship, or if we just plain forget how to engage with the printed word, we effectively join in a process that strengthens Group-Think, a process that would, for fear of anarchy or social rot, eliminate indivi-dual consciousness, complete with all its worthier utter-ances. Novelist Don DeLillo has said: "If serious read-ing dwindles to near nothingness, it will probably mean that the thing we're talking about when we use the word 'identity' has reached an end."

As a fiction writer I believe that stories are, in a sense, sacred — not least because they offer a chance to engage with, dwell upon, challenge, be challenged by, things not immediately universal: the taboo, the other,

the unorthodox, the inscrutable, the mysterious, the hard-to-swallow, sometimes the hard-to-sympathize-with. Stories are sacred not because they teach lessons or propound theories, ideas, or morals — but because they create an experience, they invite reflection, they provoke a long gaze. Because, in one mysterious way or another, they bring us home to ourselves; that is, they bring me home to myself *and* to yourself.

In today's techno culture we should, I believe, take special care not to censor ourselves or to limit our own access to books of all kinds or to quality time with the printed page. I believe we should keep it a point of honor to log out, power off, quiet down, and remind ourselves how to be alone with a book. This act of cultural defiance — reading books on a daily basis — is good for human consciousness, and it is our best and most reliable weapon against censorship, and against the Group-Think that engenders it. We will never be safe from censorship, but where individual readers are strong we are safest.

Tonight, therefore, I want to borrow the recent words of Junot Diaz, 2008 Pulitzer Prize winner:

> Let us give thanks to that most important agent of change, gathered here in great strength, let us give thanks to readers. ... We readers, I suspect, will be remembered more than any individual writer for safeguarding that delicate web of human interconnectivity that so many forces wish to buy, capture, enslave, and mine. Readers will

be remembered long after we are all gone for holding the line against the dehumanizing forces of our civilization.

So please, keep reading — or read more.

VIII.

A SOLIDARITY INDEX

The Bhagavad Gita

Be intent on action,
not on the fruits of action;
avoid attraction to the fruits
and attachment to inaction!

Perform actions, firm in discipline,
relinquishing attachment;
be impartial to failure and success,
this equanimity is called discipline.
—translator: Barbara Stoler Miller

Saul Bellow

Now, I know you haven't seen anything like my book
among recent novels. I've been reviewing them; I
know what they are. They're for the most part phony, or
empty-hearted, banal and bungling. I should have
thought it would do something to you to see *Augie*. By
your own admission you had almost finished reading the
manuscript, and yet you had nothing to say about it. You
were cool; businesslike, merely; you were terribly pa-
tronizing and you put me in a rage. In London you had
made me feel — or tried to make me feel — that you
had done me an immense favor in publishing my novels.

I will *not* be made to feel that about *Augie March*. It damned well isn't necessary.

—from a letter to John Lehmann of John Lehmann Ltd., July 19, 1951. Found in *Saul Bellow: Letters,* edited by Benjamin Taylor

John Berger

[The artist] finds within his medium the equivalent of the qualities he feels to be lacking in life. Every formal quality has its emotional equivalent. Then he begins the endless task of trying to interpret reality with these qualities always inherent in his interpretation. Perhaps no one but an artist can quite understand this. Yet it is the fundamental way in which we set out to improve the world. Is it only a subjective improvement? No, because a true work of art communicates and so extends consciousness of what is possible.

—*A Painter of Our Time* (1958)

Wendell Berry

A poem reminds us … of the spiritual elation that we call 'inspiration' or 'gift.' … It is amateur work, lover's work. What we now call 'professionalism' is anathema to it. A good poem reminds us of love because it cannot be written or read in distraction; it cannot be written or understood by anyone thinking of praise or publication or promotion. … Professional standards, the standards of ambition and selfishness, are always sliding downward toward expense, ostentation, and mediocrity. They tend

always to narrow the ground of judgment. But amateur standards, the standards of love, are always straining upward toward the humble and the best. They enlarge the ground of judgment.

—from "The Responsibility of the Poet," found in *What Are People For?*

Daniel Boorstin

The danger to our sense of reality is not that movies should be made of novels, and vice versa. But rather that we should lose our sense that neither can become the other, that the traditional novel form continues to enlarge our experience in those very areas where the wide-angle lens and the Cinerama screen tend to narrow it. The danger is not in the interchangeableness of the story, but in our belief in the interchangeableness of the forms.

—from *The Image: A Guide to Pseudo-Events in America* (1962)

Alain de Botton

The value of a novel is not limited to its depictions of emotions and people akin to those in our own life; it stretches to an ability to describe these *far better* than we would have been able, to put a finger on perceptions that we recognize *as our own,* but could not have formulated *on our own.* ... An effect of reading a book which has devoted attention to noticing such faint but vital tremors is that once we've put the volume down and resumed our own life, we may attend to precisely the things the author would have responded to had he or she been in

our company. Our mind will be like a radar newly attuned to pick up certain objects floating through consciousness. … Our attention will be drawn to the shades of the sky, to the changeability of a face, to the hypocrisy of a friend, or to a submerged sadness about a situation which we had previously not even known we could feel sad about. The book will have *sensitized* us, stimulated our dormant antennae by evidence of its own developed sensitivity. … Hence Proust's assertion that the greatness of works of art has nothing to do with the apparent quality of their subject matter, and everything to do with the subsequent treatment of that matter.

—from *How Proust Can Change Your Life*

Joseph Brodsky

Possessing its own genealogy, dynamics, logic, and future, art is not synonymous with, but at best parallel to history; and the manner by which it exists is by continually creating a new aesthetic reality. … Nowadays, there exists a rather widely held view, postulating that in his work a writer, in particular a poet, should make use of the language of the street, the language of the crowd. For all its democratic appearance, and its palpable advantages for a writer, this assertion is quite absurd and represents an attempt to subordinate art, in this case, literature, to history. It is only if we have resolved that it is time for Homo sapiens to come to a halt in his development that literature should speak the language of the

people. Otherwise, it is the people who should speak the language of literature.

—from Brodsky's Nobel Prize Speech, 1987

Frederick Busch

In the art about which you're serious, you seek, willy-nilly, examinations of and metaphors about the heat of your existence. Even if your blood has run cold, you don't want anybody else being cool about such times. They are your times, and you were on the face of this earth in trouble or love, and while you are perfectly willing to be attractively disenchanted and invulnerable in public when you need to, you know that the warmth of flesh, the muddiness of earth, the terror of madness and death, the hugeness of institutions, and the brevity of your life and the lives of those you need are what your seriousness involves. Such moments help you to define your morality. You seek them and it in the art you make or surrender to. What resorts to trend and gossip, to evasion and gloss, to the cutely second-rate, or what drops its bucket all the little inches down into the muck and gravel of jargon and career, is the opposite of what your soul requires, and it's bad.

—from "Bad," found in *A Dangerous Profession.*

Italo Calvino

It seems to me that language is always used in a random, approximate, careless manner, and this distresses me unbearably. Please don't think that my reaction is the result

of intolerance toward my neighbor: the worst discomfort of all comes from hearing myself speak. That's why I try to talk as little as possible. If I prefer writing, it is because I can revise each sentence until I reach the point where — if not exactly satisfied with my words — I am able at least to eliminate those reasons for dissatisfaction that I can put a finger on. Literature — and I mean the literature that matches up to these requirements — is the Promised Land in which language becomes what it really ought to be.

It sometimes seems to me that a pestilence has struck the human race in its most distinctive faculty — that is, the use of words. It is a plague afflicting language, revealing itself as a loss of cognition and immediacy, an automatism that tends to level out all expression into the most generic, anonymous, and abstract formulas, to dilute meanings, to blunt the edge of expressiveness, extinguishing the spark that shoots out from the collision of words and new circumstances.

... I don't wish to dwell on the possible sources of this epidemic, whether they are to be sought in politics, ideology, bureaucratic uniformity, the monotony of the mass media, or the ways the schools dispense the culture of the mediocre. What interests me are the possibilities of health. Literature, and perhaps literature alone, can create the antibodies to fight this plague in language.

—from *Six Memos for the Next Millennium*

Cyril Connolly

One further question is raised by Maugham. 'I have never had much patience,' he states, 'with the writers who claim from the reader an effort to understand their meaning.' This is an abject surrender, for it is part of the tragedy of modern literature that the author, anxious to avoid mystifying the reader, is afraid to demand of him any exertions. 'Don't be afraid of me,' he exclaims, 'I write exactly as I talk —no, better still — exactly as you talk.' Imagine Cezanne painting or Beethoven composing 'exactly as he talked'! The only way to write is to consider the reader to be the author's equal; to treat him otherwise is to set a value on illiteracy, and so all that results from Maugham's condescension to a reader from whom he expects no effort is a latent hostility.
—from *The Enemies of Promise*

e.e. cummings

So far as I am concerned, poetry and every other art was and is and forever will be strictly and distinctly a question of individuality. If poetry were anything — like dropping an atombomb — which anyone did, anyone could become a poet merely by doing the necessary anything; whatever that anything might or might not entail. But (as it happens) poetry is being, not doing. If you wish to follow, even at a distance, the poet's calling … you've got to come out of the measurable doing universe into the immeasurable house of being. I am quite aware that, wherever our socalled civilization has slithered, there's every reward and no punishment for unbeing.

But if poetry is your goal, you've got to forget all about punishments and all about rewards and all about self-styled obligations and duties and responsibilities etcetera ad infinitum and remember one thing only: that it's you — nobody else — who determine your destiny and decide your fate. Nobody else can be alive for you; nor can you be alive for anybody else.

—from *Six Nonlectures*

Nicholas Delbanco

No one presumes to give a dance recital without having first mastered the rudiments of dance, to perform Mozart before they've learned scales, or to enter a weight-lifting contest if they've never hoisted weights. Because we've been reading since five, however, we blithely assume we can read; because we scrawled our signature when six, we glibly aspire to write.

Our language is a rich and complex thing, and the conscious, conscientious study of rhetoric has largely disappeared. ... The keepers of the language-keys are less and less committed to the 'high style' as common parlance, or something to aspire to; the various subsets of regional discourse, street-slang and dialect have taken center stage. ... The time is long past since we expected our students to master their Latin and muster their Greek. Instead, the injunction, 'Know thyself,' now seems to suffice for a book. ...

Yet this whole impulse towards self-expression is a recent and possibly aberrant one in art. Legions of accomplished writers found nothing shameful in pre-

scribed or proscribed subjects, nor in eschewing the first-person pronoun. The apprentice in an artist's shop might mix paint for years or learn to dado joints for what must have felt like forever; only slowly and under supervision might he or she approach the artifact as such. Though you come prepared to write your own life's story, or that of a St. Jago's monkey your great uncle trained while plying the Sargasso Sea, have patience for a season, please; that's not our purpose here.
—from "Dear Franz K," found in *Letters to a Fiction Writer*

Don DeLillo

When my head is in the typewriter the last thing on my mind is some imaginary reader. I don't have an audience; I have a set of standards. ... The novel's not dead, it's not even seriously injured, but I do think we're working in the margins, working in the shadows of the novel's greatness and influence. ... When we talk about the novel we have to consider the culture in which it operates. Everything in the culture argues against the novel, particularly the novel that tries to be equal to the complexities and excesses of the culture. ... The novel is still spacious enough and brave enough to encompass enormous areas of experience. We have a rich literature. But sometimes it's a literature too ready to be neutralized, to be incorporated into the ambient noise. This is why we need the writer in opposition, the novelist who writes against power, who writes against the corporation

or the state or the whole apparatus of assimilation. We're all one beat away from becoming elevator music. —from *The Paris Review, issue 128, Fall 1993*

John Dewey

[There is a] distinction between expression and statement. Science states meanings. Art expresses them. ... The poetic as distinct from the prosaic, aesthetic art as distinct from scientific, expression as distinct from statement, does something different from leading to an experience. It constitutes one. ... An intellectual statement is valuable in the degree in which it conducts the mind to many things all of the same kind. It is effective in the extent to which, like an even pavement, it transports us easily to many places. The meaning of an expressive object, on the contrary, is individualized. ... Art throws off the covers that hide the expressiveness of experienced things; it quickens us from the slackness of routine and enables us to forget ourselves by finding ourselves in the delight of experiencing the world about us in its varied qualities and forms. ... Indifference to response of the immediate audience is a necessary trait of all artists that have something new to say. But they are animated by a deep conviction that since they can only say what they have to say, the trouble is not with their work but those who, having eyes, see not, and having ears, hear not. Communicability has nothing to do with popularity. ... The material expressed cannot be private; that is the state of the mad-house. But the *manner* of

saying it is individual, and, if the product is to be a work of art, induplicable.

—from *Art As Experience* (1934)

Annie Dillard

The writer studies literature, not the world. He lives in the world; he cannot miss it. If he has ever bought a hamburger, or taken a commercial airplane flight, he spares his readers a report of his experience. He is careful of what he reads, for that is what he will write. He is careful of what he learns, because that is what he will know. ... You adapt yourself, Paul Klee said, to the contents of the paintbox. Adapting yourself to the contents of the paintbox, he said, is more important than nature and its study. The painter, in other words, does not fit the paints to the world. He most certainly does not fit the world to himself. He fits himself to the paint. The self is the servant who bears the paintbox and its inherited contents. ... A well-known writer got collared by a university student who asked, 'Do you think I could be a writer?' 'Well,' the writer said, 'I don't know ... Do you like sentences?' The writer could see the student's amazement. Sentences? Do I like sentences? I am twenty years old and do I like sentences? If he liked sentences, of course, he could begin, like a joyful painter I knew. I asked him how he came to be a painter. He said, 'I liked the smell of the paint.' ... If you ask a twenty-one-year-old poet whose poetry he likes, he might say, unblushing, 'Nobody's.' In his youth, he has not yet understood that poets like poetry, and novelists like novels; he

himself likes only the role. The thought of himself in a
hat.
—from *The Writing Life*

T.S. Eliot

Tradition ... cannot be inherited, and if you want it you
must obtain it by a great labor. It involves, in the first
place, the historical sense, which we may call nearly in-
dispensable to anyone who would continue to be a poet
beyond his twenty-fifth year; and the historical sense
involves a perception, not only of the pastness of the
past, but of its presence; the historical sense compels a
man to write not merely with his own generation in his
bones, but with a feeling that the whole of the literature
of Europe from Homer and within it the whole of the
literature of his own country has a simultaneous exis-
tence and composes a simultaneous order. ...

No poet, no artist of any art, has his complete mean-
ing alone. His significance, his appreciation is the ap-
preciation of his relation to the dead poets and artists.
You cannot value him alone; you must see him, for con-
trast and comparison, among the dead. I mean this as a
principle of aesthetic, not merely historical, criticism. ...
What happens when a new work of art is created is
something that happens simultaneously to all the works
of art which preceded it. ...The poet who is aware of this
will be aware of great difficulties and responsibilities. ...

He must be quite aware of the obvious fact that art
never improves, but that the material of art is never quite
the same. ... What is to be insisted upon is that the poet

must develop or procure the consciousness of the past and that he should continue to develop this consciousness throughout his career.

What happens is a continual surrender of himself as he is at the moment to something which is more valuable. The progress of an artist is a continual self-sacrifice, a continual extinction of personality. ...

The emotion of art is impersonal. And the poet cannot reach this impersonality without surrendering himself wholly to the work to be done.

—from "Tradition and the Individual Talent," found in *The Sacred Wood*

John Gardner

Because his art is such a difficult one, the writer is not likely to advance in the world as visibly as do his neighbors: while his best friends from high school or college are becoming junior partners in prestigious law firms, or opening their own mortuaries, the writer may be still sweating out his first novel. Even if he has published a story or two in respectable periodicals, the writer doubts himself. ... The writer must somehow convince himself that he *is* in fact serious about life, so serious that he is willing to take great risks. If you have taken the time to learn to write beautiful, rock-firm sentences, if you have mastered evocation of the vivid and continuous dream, if you are generous enough in your personal character to treat imaginary characters and readers fairly, if you have held on to your childhood virtues and have not settled for literary standards much lower than those

of the fiction you admire, then the novel you write will eventually be, after the necessary labor of repeated revision, a novel to be proud of, one that almost certainly someone, sooner or later, will be glad to publish. ... Novel writing is not so much a profession as a yoga, or 'way,' an alternative to ordinary life-in-the-world. Its benefits are quasi-religious — a changed quality of mind and heart, satisfactions no non-novelist can understand — and its rigors generally bring no profit except to the spirit. For those who are authentically called to the profession, spiritual profits are enough.

—from *On Becoming a Novelist*

George Gissing

I surmise that the path of 'literature' is being made too easy. Doubtless it is a rare thing nowadays for a lad whose education ranks him with the upper middle class to find himself utterly without resources, should he wish to devote himself to the profession of letters. And there is the root of the matter; writing has come to be recognized as a profession, almost as cut-and-dried as church or law; a lad may go into it with full parental approval, with ready avuncular support. I heard not long ago of an eminent lawyer who had paid a couple hundred per annum for his son's instruction in the art of fiction — yea, the art of fiction — by a not very brilliant professor of that art. ... Starvation, it is true, does not necessarily produce fine literature; but one feels uneasy about these carpet-authors. To the two or three who have a measure of conscience and vision, I could wish, as the best thing,

some calamity which would leave them friendless in the streets. They would perish, perhaps. But set that possibility against the all but certainty of their present prospect — the fatty degeneration of the soul; and is it not acceptable? I thought of this as I stood yesterday watching a noble sunset, which brought back to my memory the sunsets of a London autumn, thirty years ago; more glorious, it seems to me, than any I have since beheld. It happened that, on one such evening, I was by the river at Chelsea, with nothing to do except to feel that I was hungry, and to reflect that, before morning, I should be hungrier still. I loitered upon Battersea Bridge — the old picturesque wooden bridge — and there the western sky took hold upon me. Half an hour later I was speeding home. I sat down and wrote a description of what I had seen, and straightaway sent it to an evening newspaper, which, to my astonishment, published the thing next day — 'On Battersea Bridge.' How proud I was of that little bit of writing! I should not much like to see it again, for I thought it then so good that I am sure it would give me an unpleasant sensation now. Still, I wrote it because I enjoyed doing so, quite as much as because I was hungry; and the couple of guineas it brought me had as pleasant a ring as any money I ever earned.

—from *The Private Papers of Henry Ryecroft* (1903)

Donald Hall

When I take a sentence in my hand, raise it to the light, rub my hand across it, disjoin it, put it back together again with a comma added, raising the pitch in the front

part; when I rub the grain of it, comb the fur of it, reassemble the bones of it, I am making something that carries with it the sound of a voice, the firmness of a hand. Maybe little more. On the other hand there is no thought without style. Unless language taps chisel into stone, nothing is being thought. By itself the stone is only the blunt opacity of an area for thinking in; the stylus does the thinking — by cutting, by making clean corners, by incising. When we believe in translation into concepts, philosophy or poetry, we do not really think. Of course, when you use the stylus you are not necessarily thinking. But *unless* you use the stylus you are *certainly* not thinking.

—from "Working Journal," found in *Our Private Lives: Journals, Notebooks, and Diaries*

Václav Havel
If we start with the presupposition that art constitutes a distinctive way of seeking the truth — truth in the broadest sense of the word, that is, chiefly the truth of the artist's inner experience — then there is only one art, whose sole criterion is the power, the authenticity, the revelatory insight, the courage and suggestiveness with which it seeks its truth, or perhaps the urgency and profundity of this truth. … The prospect of public recognition and lucrative commissions in our country, today more than at other times and in other places, is incompatible with that stubborn, uncompromising effort to reach out for some personal truth without which, it seems, there can be no real art. The more an artist

compromises to oblige power and gain advantages, the less good art can we expect from him; the more freely and independently, by contrast, he does his own thing — whether with the expression of a 'rebellious bohemian' or without it — the better his chances of creating something good — though it remains only a chance: what is uncompromising need not automatically be good. ... Every meaningful cultural act — wherever it takes place — is unquestionably good in and of itself, simply because it exists and because it offers something to someone. Yet can this value 'in itself' really be separated from 'the common good'? Is not one an integral part of the other from the start? Does not the bare fact that a work of art has meant something to someone — even if only for a moment, perhaps to a single person — already somehow change, however minutely, the overall condition for the better? ... Can we separate the awakening human soul from what it always, already is — an awakening human community?

—from "Six Asides About Culture," found in *Open Letters: Selected Writings 1965-1990*

Robert Henri

The work of the art student is no light matter. Few have the courage and stamina to see it through. You have to make up your mind to be alone in many ways. We like sympathy and we like to be in company. It is easier than going it alone. But alone one gets acquainted with himself, grows up and on, not stopping with the crowd. It costs to do this. If you succeed somewhat you may have

to pay for it as well as enjoy it all your life. ... An art student must be a master from the beginning; that is, he must be master of such as he has. By being now master of such as he has there is promise that he will be master in the future. ...

The brush stroke at the moment of contact carries inevitably the exact state of being of the artist at that exact moment into the work, and there it is, to be seen and read by those who can read such signs, and to be read later by the artist himself, with perhaps some surprise, as a revelation of himself.

For an artist to be interesting to us he must have been interesting to himself. He must have been capable of intense feeling, and capable of profound contemplation.

He who has contemplated has met with himself, is in a state to see into the realities beyond the surfaces of his subject. Nature reveals to him, and, seeing and feeling intensely, he paints, and whether he wills it or not each brush stroke is an exact record of such as he was at the exact moment the stroke was made.

—from *The Art Spirit*

Werner Herzog

1) By dint of declaration the so-called Cinema Verité is devoid of verité. It reaches a merely superficial truth, the truth of accountants. 2) One well-known representative of Cinema Verité declared publicly that truth can be easily found by taking a camera and trying to be honest. He resembles the night watchman at the Supreme Court who resents the amount of written law and legal proced-

ures. 'For me,' he says, 'there should be only one single law; the bad guys should go to jail.' Unfortunately, he is part right, for most of the many, much of the time. 3) Cinema Verité confounds fact and truth, and thus plows only stones. And yet, facts sometimes have a strange and bizarre power that makes their inherent truth seem unbelievable. 4) Fact creates norms, and truth illumination. 5) There are deeper strata of truth in cinema, and there is such a thing as poetic, ecstatic truth. It is mysterious and elusive, and can be reached only through fabrication and imagination and stylization. 6) Filmmakers of Cinema Verité resemble tourists who take pictures of ancient ruins of facts. 7) Tourism is sin, and travel on foot virtue.
—from the "Minnesota Declaration"

Gerard Manly Hopkins

If I had written and published works the extreme beauty of which the author himself most keenly feels and they had fallen out of sight at once and been…almost wholly unknown; then, I say, I should feel a certain comfort to be told they had been deeply appreciated by some one person, a stranger at all events, and had not been published quite in vain. Many beautiful works have been almost unknown and then have gained fame at last … but many more have been lost sight of altogether. … When I spoke of fame I was not thinking of the harm it does to men as artists: it may do them harm, as you say, but so, I think, may the want of it, if 'Fame is the spur that the clear spirit doth raise To shun delights and live laborious days' — a spur very hard to find a substitute for or to do

without. ... What I do regret is the loss of recognition belonging to the work itself. ... However I shall, in my present mind, continue to compose, as occasion shall fairly allow which I am afraid will be seldom and indeed for some years past has been scarcely ever.
—from letters to Richard Watson Dixon, 1878-1881, found in *Silences* by Tillie Olsen

Lewis Hyde
Men and women who dedicate their lives to the realization of their gifts tend the office of that communion by which we are joined to one another, to our times, to our generation, and to the race. Just as the artist's imagination 'has a gift' that brings the work to life, so in the realized gifts of the gifted spirit the group 'has a gift.' These creations are not 'merely' symbolic, they do not 'stand for' the larger self; they are its necessary embodiment, a language without which it would have no life at all. ... All cultures and all artists have felt the tension between gift exchange and the market, between the self-forgetfulness of art and the self-aggrandizement of the merchant, and how that tension is resolved has been a subject of debate since before Aristotle.

And yet some aspects of the problem are modern. ... The exploitation of the arts which we find in the twentieth century is without precedent. The particular manner in which radio, television, the movies, and the recording industry have commercialized song and drama is wholly new, for example, and their 'high finance' produces an atmosphere that all the sister arts must breathe. 'The Pa-

per Chase' may be the best show that ever came to television, but it belongs to a class of creations which will not live unless they are constantly fed large sums of money. The more we allow such commodity art to define and control our gifts, the less gifted we will become, as individuals and as a society.

—from *The Gift*: *Creativity and the Artist in the Modern World*

Henry James

It appears to me that no one can ever have made a seriously artistic attempt without becoming conscious of an immense increase — a kind of revelation — of freedom. One perceives in that case — by the light of a heavenly ray — that the province of art is all life, all feeling, all observation, all vision. … That is sufficient answer to those who … stick into its divine unconscious bosom little prohibitory inscriptions on the end of sticks, such as we see in public gardens — 'It is forbidden to walk on the grass; it is forbidden to touch the flowers; it is not allowed to introduce dogs or to remain after dark; it is requested to keep to the right.' … The first advantage of [the young writer's] taste will be to reveal to him the absurdity of the little sticks and tickets. … I cannot see what is meant by talking as if there were a part of a novel which is the story and part of it which for mystical reasons is not. … The story and the novel, the idea and the form, are the needle and the thread, and I never heard of a guild of tailors who recommended the use of the thread without the needle, or the needle without the

thread. ... I should remind [a young writer] first of the magnificence of the form that is open to him, which offers to sight so few restrictions and such innumerable opportunities. The other arts, in comparison, appear confined and hampered; the various conditions under which they are exercised are so rigid and definite. But the only condition that I can think of attaching to the composition of the novel is, as I have already said, that it be sincere. This freedom is a splendid privilege, and the first lesson of the young novelist is to learn to be worthy of it.
—from "The Art of the Novel"

William Kennedy

I am now as much awash in critical magnanimity as I was bathed two years ago in insolvent obscurity. The nature of this new status is extreme pleasure, but also part of it is residual bewilderment at the causes of the previous condition. I was once deeply resentful at the rejection of *Ironweed* — it was rejected thirteen times — but of course I am slowly coming out of that. ... It is the substance of the rejections that is disconcerting; and that substance is twofold. First: My immediately previous novel, *Billy Phelan's Greatest Game*, was not only not a bestseller, it was a worst-seller. Was the book's lack of sales the author's fault? Well, I must have had something to do with it, but I won't take full blame. Yet its failure to galvanize the American imagination in 1978 dogged my future. The line I heard most frequently was that publishers would rather take the risk on a first novelist than on a fourth novelist with a bleak track record. I

hardly think this the received wisdom of the ages — to reward the apprentice at the expense of the journeyman. Literature, I suggest, deserves a different ordering of values. Scott Fitzgerald's line that there are no second acts in American lives was the sad, solipsistic truth about that wonderful writer's self-destructive career; but for those who take this as wisdom it can be a pernicious fallacy.

—from Kennedy's National Book Critics Circle Award acceptance speech, 1984

Lewis Lapham

If in the 1950s the young and aspiring writer hoped to become a novelist or a playwright, thirty years later the ambition had been replaced with the thought of becoming a critic, a journalist, or a policy intellectual, possibly a television talking head. Instead of addressing George Orwell's concern for the safety of the English language, the conversations revolved around the names of Hollywood agents and the grooming of resumes fit for the favor of a foundation grant. ... The love of language once inherent in a distinctive literary style not only fell out of favor but was placed under suspicion as an un-American activity. Among New York editors it was assumed that a writer who clogged the data streams with arresting turns of phrase could not be trusted to impart the truth. ...

The country continues to turn up individuals making works of art — among those in the literary theaters of operation I can think of many — but they traffic in a medium of exchange on which the society doesn't place

a high priority. … The existence of a civilization presupposes a public that has both the time, and the need, to draw sustenance from the high-wire acts of the imagination. The United States has never produced such a public in commercial quantity.

—from *Lapham's Quarterly* Vol.3, No.2 Spring 2010

G.P. Leed

A literature preoccupied with language, a work that presumes to consist of sentences, is a work presumed to have 'little to say.' What is most esteemed is documentation, line after line dashed off in the hurry to encyclopediate the national life and self (but do such things exist, really?). Language that lingers appears to ignore the imperative to catalog, to gather up. For this reason a beautiful sentence is viewed with suspicion, and the book consisting of sentences is brushed aside, 'Irrelevant.' The writer has declined the beck and call of Ambition. So it's believed. The bias is strong, it permeates the culture. It will soon be beyond us, if it's not already, to recognize the infinite capacity of a line as carrier of, vessel for, doorway to — consciousness. And what else is this world — this world that so wants witnessing — made of but consciousness? To render consciousness in a sentence, in language, in the all-seeing eye of a fully created line, *this* is to render the world. We are only ourselves, however rampant the desire to upload and exponentialize individual identity. There is only consciousness *singular*, self-contained. A myriad selves. Spheres that may touch, at most, other

spheres. The social consciousness, a thing collective in nature, made up of the mass, larger itself than the sum of its parts — this collective consciousness does not exist, and a literature seeking to capture it is a literature predicated on falsity, the dreams of the technologist. The project and subject of literature is embodied in the singular self — the revolving sphere — of the sentence.
—from *The Private Papers of G.P. Leed*

C.S. Lewis

What is more surprising and disquieting is the fact that those who might be expected *ex officio* to have a profound and permanent appreciation of literature may in reality have nothing of the sort. They are mere professionals. Perhaps they once had the full response, but the 'hammer, hammer, hammer on the hard, high road' has long since dinned it out of them. ... For such people reading often becomes mere work. The text before them comes to exist not in its own right but simply as raw material; clay out of which they can complete their tale of bricks. Accordingly we often find that in their leisure hours they read, if at all, as the many read. I well remember the snub I once got from a man to whom, as we came away from an examiners' meeting, I tactlessly mentioned a great poet on whom several candidates had written answers. His attitude (I've forgotten the words) might be expressed in the form, 'Good God, man, do you want to go on *after hours*?' ... For those who are reduced to this condition by economic necessity and overwork I have nothing but sympathy. Unfortunately, ambi-

tion and combativeness can also produce it. And, however it is produced, it destroys appreciation.
—from *An Experiment in Criticism* (1961)

Longinus

Shatter the reader's composure.
Exercise irresistible domination.
Scatter the subjects like a bolt of lightning.
[Use:] Figurative Language. ... Nobility of Expression.
... Elevated Composition. ... Loftiness of Thought. ...
Strong and Inspired Passion.
—from *Peri hupsuous,* "On the Sublime" (1st century A.D.)

Norman Maclean

You must have known that Alfred A. Knopf turned down my first collection of stories after playing games with it, or at least the game of cat's paw, now rolling it over and saying they were going to publish it, and then rolling it on its back when the president of the company announced it wouldn't sell. So I can't understand how you could ask if I'd submit my second manuscript to Alfred A. Knopf, unless you don't know my race of people. ... I can only weakly say this: if the situation ever arose when Alfred A. Knopf was the only publishing house remaining in the world and I was the sole remaining author, that would mark the end of the world of books.
—from Maclean's letter to editor Charles Elliott at Alfred A. Knopf, 1981

David Mamet

It is not childish to live with uncertainty, to devote one-self to craft rather than a career, to an idea rather than an institution. It's courageous and requires a courage of the order that the institutionally co-opted are ill-equipped to perceive. They are so unequipped to perceive it that they can only call it childish, and so excuse their exploitation of you. … The best advice one can give an aspiring artist is 'Have something to fall back on.' The merit of the in-struction is this: those who adopt it spare themselves the rigor of the artistic life. … Those with 'something to fall back on' invariably fall back on it. They intended to all along. That is why they provided themselves with it. But those with no alternative see the world differently. The old story has the mother say to the sea captain, 'Take special care of my son, he cannot swim,' to which the captain responds, 'Well, then, he'd better stay in the boat.' … Those of you with nothing to fall back on, you will find, are home.
—from *True & False: Heresy and Common Sense for the Actor*

Alberto Manguel

So imbued was Nineveh with the idea that wealth was the city's goal, and that art, since it was not an immed-iate producer of wealth, was an undeserving pursuit, that the artists themselves came to believe that they should pay their own way in the world, producing cost-efficient art, frowning on failure and lack of recognition, and above all, trying to gratify those who, being wealthy,

were also in positions of power. So visual artists were asked to make their work more pleasing, composers to write music with a hummable tune, writers to imagine not-so-depressing scenarios. ... 'The real artists,' said the Ninevites, 'have no cause to complain. If they are really good at what they do, they will make a buck no matter what the social conditions. It's the others, the so-called experimenters, the self-indulgers, the prophets, who don't make a cent and whine about their condition. A banker who doesn't know how to turn a profit would be equally lost. ... This is the law of survival.' ... 'The artist,' Jonah attempted to explain, 'is *not* like any other worker in society. The artist deals with reality: inner and outer reality transformed into meaningful symbols. Those who deal in money deal in symbols behind which stands nothing. It is wonderful to think of the thousands and thousands of Ninevite stockbrokers for whom reality, the real world, is the arbitrary rising and falling of figures transformed in their imagination into wealth — a wealth that exists only on a piece of paper or on a flickering screen. ... Grown-up men and women who will not for a minute consider the reality of the unicorn, even as a symbol, will accept as rock-hard fact that they possess a share in the nation's camel bellies, and in that belief they consider themselves happy and secure.'

By the time Jonah had reached the end of this paragraph, the public square in Nineveh was deserted.
—from "Jonah and the Whale," found in *Into the Looking-Glass Wood*

Each new writer who, in the eyes of even one reader, becomes essential to understanding the world, changes history, provides a new order, demands a new reading of the past. ... 'Poets in our civilization,' said Eliot, 'must be difficult.' Our tired times, however, have led us to avoid the difficult or, worse, to regard it as ostentatious and pedantic. We are asked to accept this paradox: that what is profound is superfluous. This has become our excuse for being lazy. Of course, at all times readers have had silly rules dictating their fashion in literature. ... Readers mature later than writers and require certain mysterious preparations to receive them properly. Fortunately, good writing is persistent. It will not go away. It is there to translate much of our dealing with the world and with ourselves, to give voice to our questions. It isn't easy, in the sense that language itself isn't easy, but it is clear and resonant. We, of course, have no obligation to listen to its echo. As usual, we have the choice of remaining deaf.

—from "Waiting for an Echo," found in *Into the Looking-Glass Wood*

Toni Morrison

I was always conscious of the constructed aspect of the writing process, and that art appears natural and elegant only as a result of constant practice and awareness of its formal structures. You must practice thrift in order to achieve that luxurious quality of wastefulness — that sense that you have enough to waste, that you are holding back — without actually wasting anything. You

shouldn't over-gratify, you should never satiate. I've always felt that that particular sense of hunger at the end of a piece of art — a yearning for more — is really very, very powerful. But there is at the same time a kind of contentment, knowing that at some other time there will indeed be more because the artist is endlessly inventive.
—from *The Paris Review, issue 128, Fall 1993*

Tillie Olsen

It does not help the work to be done, that work already completed is surrounded by silence and indifference — if it is published at all. Few books ever have the attention of a review — good or bad. Fewer stay longer than a few weeks on bookstore shelves, if they get there at all. New books are always coming in. Quality or ephemera — if the three- or four-week-old one hasn't yet made best-sellerdom or the book clubs (usually synonymous) — Out! Room must be made. ... 'Works of art' (or at least books, stories, poems, meriting life) 'disappear before our very eyes because of the absence of responsible attention,' Chekhov wrote nearly ninety years ago. Are they even seen? ... Critics and academics tend to invoke the same dozen or so writers as if none else exist worthy of mention, or as if they've never troubled to read anyone else. Anthologies, textbooks, courses concerned with contemporary literature, tend to be made up of living writers whose names will immediately be recognized (usually coincident with writers whom publishers have promoted). ... Published writers of good books, if their books haven't been respectable

money-makers, more and more find themselves without a publisher for their latest one. ... At a time when there is more reading and *writing* of imaginative literature than any time in the human past (and an indiscriminate glut of books on the market), and a greater potential audience than ever before, it is harder and harder for the serious writer to get published or get to readers once published. Another way of saying it: Writers in a profit making economy are an exploitable commodity whose works are products to be marketed, and are so judged and handled. That happier schizophrenic time when publishers managed profit necessities in combination with some commitment to literature of quality and content, is less and less possible. Almost *all* publishing houses are now owned by conglomerates who bought them for investment purposes ... and whose only concern (necessarily) is high profit return. Why diversify, take risks, settle for modest returns, take trouble — and literature *is* trouble. ... The attitude: nobody owes you (the writer) anything; the world never asked you to write. My long ago and still instinctive response: What's wrong with the world then, that it doesn't ask — and make it possible — for people to raise and contribute the best that is in them.
—from *Silences*

Cynthia Ozick
With High Art in the form of the novel having lost its centrality, the nature of ambition too was bound to alter. This is not to say that young writers today are no longer

driven — and some may even be possessed — by the strenuous forces of literary ambition. Zeal, after all, is a constant, and so must be the pool, or the sea, of born writers. But the great engines of technology lure striving talents to television and Hollywood, or to the lighter varieties of theater, or (especially) to the prompt gratifications and high-velocity fame of the magazines, where topical articles generate buzz and gather no moss. The sworn novelists, who despite the devourings of the hour, continue to revere the novel (the novel as moss, with its leisurely accretions of character and incident, its disclosures of secrets, its landscapes and cityscapes and mindscapes, its idiosyncratic particularisms of language and insight) — these sworn novelists remain on the scene, if not on the rise.

—from *The Din in the Head*

Among fiction writers the fossilized Hemingway legacy hangs on, after all this time, strangely and uselessly prestigious. (I attribute this not to the devoted reading of Hemingway, but to the decline of reading in general.)

—from "Cyril Connolly and the Groans of Success," found in *Metaphor & Memory*

Writers are what they genuinely are only when they are at work in the silent and instinctual cell of ghostly solitude, and never when they are out industriously chatting on the terrace. ... Art turns mad in pursuit of the false face of wishful distraction. The fraudulent writer is the visible one, the crowd-seeker, the crowd-speaker, the

one who will go out to dinner with you with a motive in mind, or will stand and talk at you, or will discuss mutual writing habits with you, or will gossip with you about other novelists and their enviable good luck or their gratifying bad luck. The fraudulent writer is like Bellow's Henderson: 'I want, I want, I want.' If all this is so — and it is so — then how might a young would-be writer aspire to join the company of the passionately ghostly invisibles? Or, to put it another way, though all writers are now and again unavoidably compelled to become visible, how to maintain a coveted, clandestine, authentic invisibility?
—from Ozick's PEN/Nabokov Award acceptance speech

Jayne Anne Phillips

People love turning their backs on writers, as they will, repeatedly, turn their backs on themselves. Inside culture, the writer is the talking self. Through history, the writing that lasts is the whisper of conscience, and history regards individual voices in various ways at various times according to the dictates of fashion, whimsy, values, politics. The guild of outcasts is essentially a medieval guild existing in a continual Dark Age, shaman/monks, witch/nuns, working in isolation, playing with fire. When the first illuminated manuscripts were created, few people could read. Now that people are bombarded with image and information and the World Wide Web is an open vein, few people can read. Reading with sustained attention, reading for under-

standing, reading to cut through random meaningless-
ness — such reading becomes a subversive act. We're
not talking detective books, romance, cookbooks, or
self-help. We're talking about the books writers read to
feel themselves among allies, to feed themselves, to
reach across time and distance, to hope. ... The writer's
first affinity is not to a loyalty, a tradition, a morality, a
religion, but to life itself, and to its representation in
language. Nothing is taboo. The writer will go any-
where, say anything to get it said; in fact, the writer is
bent on doing so. The writer is bent.
—from "Why I Write"

Katherine Anne Porter

My dear fellow artists, I suggest that you go ahead and
do your work and do it as you please and refuse to allow
any force, any influence (that is to say, any editor or
publisher) to tamper with your life or to debase your
work. You are practicing an art and they are running a
business and just keep this in mind.
—found in Tillie Olsen's *Silences*

Herbert Read

No one will deny the profound interrelation of artist and
community. The artist depends on the community —
takes his tone, his tempo, his intensity from the society
of which he is a member. But the individual character of
the artist's work depends on more than these: it depends
on a definite will-to-form which is a reflection of the art-
ist's personality, and there is no significant art without

this act of creative will. ... The ultimate values of art transcend the individual and his time and circumstance. They express an ideal proportion or harmony which the artist can grasp only in virtue of his intuitive powers. In expressing his intuition the artist will use materials placed in his hands by the circumstances of his time: at one period he will scratch on the walls of his cave, at another he will build or decorate a temple or a cathedral, at another he will paint on canvas for a limited circle of connoisseurs. The true artist is indifferent to the materials and conditions imposed upon him. He accepts any conditions, so long as they can be used to express his will-to-form. Then in the wider mutations of history his efforts are magnified or diminished, taken up or dismissed, by forces which he cannot predict, and which have very little to do with the values of which he is the exponent. It is his faith that those values are nevertheless among the eternal attributes of humanity.

—from *The Meaning of Art* (1931)

Jules Renard

The profession of letters is, after all, the only one in which one can make no money without being ridiculous.

—from *The Journal of Jules Renard,* Sept. 1906

John Ruskin

The richness of the work is, paradoxical as the statement may appear, a part of its humility. No architecture is so haughty as that which is simple; which refuses to ad-

dress the eye, except in a few clear and forceful lines; which implies, in offering so little to our regards, that all it has offered is perfect; and disdains, either by the complexity or attractiveness of its features, to embarrass our investigation, or betray us into delight.
—from *The Stones of Venice, Vol. 2* (1853)

Lee Siegel

The arts are losing their capacity to create an original experience, though no one has been able to say why. It seems harder and harder to make a work of art that does not conform to the dictates of the trivializing media, or that does not follow the lead of marketing experts. ... It's often the artists themselves — novelists, painters, filmmakers, television writers — who seem to believe that art is exploitable for nonartistic purposes. They seem to have given up on the idea of art as an autonomous end. Making art now often serves as a means to advancement. ... Art has become more, as the people in the personnel department like to say, 'goal-oriented.' ... This has a terrible effect on art-making. The general anxiety now is that if you don't have a gallery, or a movie about to be released, or a six-figure advance for a book soon after college, you have bungled opportunities previously unknown to humankind. ... Learning to make art takes time. But instead of the artist patiently surrendering his ego to the work, he uses his ego to rapidly direct the work along extra-artistic shortcuts,

toward the success that seems to be diffused all around him like sunshine.

—from *Falling Upwards: Essays in Defense of the Imagination*

Susan Sontag

The subtraction of beauty as a standard for art hardly signals a decline of the authority of beauty. Rather, it testifies to a decline in the belief that there is something called art. ... As the relativistic stance in cultural matters pressed harder on the old assessments, definitions of beauty — descriptions of its essence — became emptier. ... The failure of the notion of beauty reflects the discrediting of the prestige of judgment itself, as something that could conceivably be impartial or objective, not always self-serving or self-referring. ... Similarly, there is more and more resistance to the idea of 'good taste,' that is, to the dichotomy of good taste/bad taste, except for occasions that allow one to celebrate the defeat of snobbery and the triumph of what was once condescended to as bad taste. Today, good taste seems even more retrograde an idea than beauty. Austere, difficult 'modernist' art and literature have come to seem old-fashioned, a conspiracy of snobs. Innovation is relaxation now; today's E-Z Art gives the green light to all. In the cultural climate favoring the more user-friendly art of recent years, the beautiful seems, if not obvious, then preten-

tious. Beauty continues to take a battering in what are called, absurdly, our cultural wars.
—from "An Argument about Beauty," found in *At the Same Time: Essays and Speeches*

Stephen Spender

One result of the pressure on publishers to sell larger quantities of each book they publish is direct and indirect pressure on writers to write books which will sell in large quantities. ... It becomes increasingly difficult to publish a first book, unless this achieves the orthodoxy of sex and sensation which is becoming to a bestseller. 'Editors,' introduced into publishing houses, suggest to writers how they should alter their books in order to make plot and character exciting and saleable. Books are often altered and in some cases rewritten by the same editors. In rewriting, the editors bear it in mind that the book may be made into a movie. Publishers show a tendency to treat manuscripts as scripts. It is not unthinkable that American publishing houses will one day employ professional writers who systematically shape into synthetic bestsellers the manuscripts submitted to them by a sad dying-out race of writers. Some editors are already in touch with promising young writers at universities, 'discovering' them and at the same time revealing to their innocent minds that writing is one thing, and selling what one writes, another. The teachers of 'creative writing courses' cannot altogether ignore 'the market' and all this implies: what it implies, indeed, is that you either have to get on to it or be a teacher of a

creative writing course. The general effect of increasing commercialization and of the compulsion to sell ever larger and larger quantities of a few books to a public which does not really care about them, must surely be that the position of the writer who writes as well as he possibly can 'to please himself', becomes less tenable. ... Fiction comes to resemble journalism, and journalism fiction. The 'stories' in the news move in the same world of journalistic, glamorized unreality as the stories in the popular magazines. Both have been robbed of their authenticity; journalism of its directness, and fiction of its art. ... The American malady is a spiritual one, the commercialization of spiritual goods on an enormous scale, in the same way as material goods are commercialized. ... In the country where culture is 'sold' enormously, it is sold as something other than culture and tends to become something else in the process.

—from "The Situation of the American Writer" (1949), found in *The Making of a Poem*

Wallace Stegner

You are scheduled — doomed — to be a serious writer regarding life seriously and reporting it to a small audience. ... Not many of your countrymen will read you or know your name, not because they are Americans, or moderns, or especially stupid, but because they are human. Your kind of writer has never spoken to a large audience except over a long stretch of time, and I would not advise you to pin too much hope even on posterity.

Your touch is the uncommon touch; you will speak only to the thoughtful reader. ... The readers do exist. ... Any of them you find you will treasure. This audience, by and large, will listen to what you say and not demand that you say what everyone else is saying or what some fashionable school or clique says you should say. ... Be grateful for them. But however grateful you are, never, never write to please them. ... You write to satisfy yourself and the inevitabilities of the situation you have started into motion. You write under a compulsion, it is true, but it is the compulsion of your situation, not of a private hatred or envy or fear; and you write to satisfy yourself, but you write always in the remote awareness of a listener — O'Connor's man in the arm chair. He responds to what you respond to and understands what you understand. Above all, he listens. Being outside of you, he closes a circuit, he is an ear to your mouth. Unless at least one like him reads you, you have written uselessly. Your book is as hypothetical as the sound of the tree that falls in the earless forest. ...Write what *you* like. When your book is published, you will have a letter from at least one of him, perhaps from as many as twenty or thirty of him. With luck, as other books come on his numbers will grow. But to you he will always be a solitary reader, an ear, not an audience. Literature speaks to temperament, Conrad says. Your books will find the temperaments they can speak to.

—from "To a Young Writer," found in *Wallace Stegner on Teaching and Writing Fiction*

John Steinbeck

I want to write this one as though it were my last book. Maybe I believe that every book should be written that way. I think I mean that. It is the ideal. And I have done just the opposite. I have written each book as an exercise, as practice for the one to come. And this is the one to come. There is nothing beyond this book — nothing follows it. ... And I must forget even that I want it to be good. Such things belong only in the planning stage. Once it starts, it should not have any intention save to be written. ... Just remember that this book is going on forever. I do not intend ever to finish it. And only with this attitude will it progress as I wish it to.

—from *Journal of a Novel: the East of Eden Letters*

Strunk & White

When we speak of Fitzgerald's style, we don't mean his command of the relative pronoun, we mean the sound his words make on paper. Every writer, by the way he uses the language, reveals something of his spirit, his habits, his capacities, his bias. ... Young writers often suppose that style is a garnish for the meat of prose, a sauce by which a dull dish is made palatable. Style has no such separate entity; it is non-detachable, unfilterable. The beginner should approach style warily, realizing that it is himself he is approaching, no other; and he should begin by turning resolutely away from all devices that are popularly believed to indicate style — all mannerisms, tricks, adornments. The approach to style is by way of plainness, simplicity, orderliness,

sincerity. ... 'But,' the student may ask, 'what if it comes natural to me to experiment rather than to conform? What if I am a pioneer, or even a genius?' Answer: then be one. But do not forget that what may seem like pioneering may be merely evasion, or laziness — the disinclination to submit to discipline. Writing good standard English is no cinch, and before you have managed it you will have encountered enough rough country to satisfy even the most adventurous spirit.

Style takes its final shape more from attitudes of mind than from principles of composition, for as an elderly practitioner once remarked, 'Writing is an act of faith, not a trick of grammar.' This moral observation would have no place in a rulebook were it not that style *is* the writer, and therefore what a man is, rather than what he knows, will at last determine his style. If one is to write, one must believe — in the truth and worth of the scrawl, in the ability of the reader to receive and decode the message. No one can write decently who is distrustful of the reader's intelligence, or whose attitude is patronizing.

... It is now necessary to warn the writer that his concern for the reader must be pure: he must sympathize with the reader's plight (most readers are in trouble about half the time) but never seek to know his wants. The whole duty of a writer is to please and satisfy himself, and the true writer always plays to an audience of one. Let him start sniffing the air, or glancing at the

Trend Machine, and he is as good as dead, although he
may make a nice living.
—from *The Elements of Style*

Henry David Thoreau

In literature it is only the wild that attracts us. Dullness
is but another name for tameness. It is the uncivilized
free and wild thinking in Hamlet and the Iliad, in all the
scriptures and mythologies, not learned in the schools,
that delights us. As the wild duck is more swift and
beautiful than the tame, so is the wild — the mallard —
thought, which 'mid falling dews wings its way above
the fens.' A truly good book is something as natural, and
as unexpectedly and unaccountably fair and perfect, as a
wildflower discovered on the prairies of the West or in
the jungles of the East. Genius is a light which makes
the darkness visible, like the lightning's flash, which
perchance shatters the temple of knowledge itself — and
not a taper lighted at the hearthstone of the race, which
pales before the light of common day.
—from "Walking" (1862)

Lionel Trilling

If we look at the commercially successful serious novels
of the last decade, we see that almost all of them have
been written from an intense social awareness — it
might be said that our present definition of a serious
book is one which holds before us some image of socie-
ty to consider and condemn. ... The public is probably
not deceived about the quality of most of these books. If

the question of quality is brought up, the answer is likely to be: no, they are not great, they are not imaginative, they are not 'literature.' But there is an unexpressed addendum: and perhaps they are all the better for not being imaginative, for not being literature — they are not literature, they are reality, and *in a time like this* what we need is reality in large doses. ... Reality, as conceived by us, is whatever is external and hard, gross, unpleasant. ... The word 'reality' is an honorific word and the future historian will naturally try to discover our notion of its pejorative opposite, appearance, mere appearance. He will find it in our feeling about the internal; whenever we detect evidences of style and thought we suspect that reality is being a little betrayed, that 'mere subjectivity' is creeping in. There follows from this our feeling about complication, modulation, personal idiosyncrasy, and about social forms, both the great and the small.

—from "Manners, Morals, and the Novel" (1947), found in *The Moral Obligation to Be Intelligent*

Dubravka Ugresic

The market has destroyed the closed artistic institutions, the academies and faculties; has trampled underfoot the old-fashioned artistic arbiters, the 'guardians of good taste,' the theoreticians of art and literature; has dismissed the stern and demanding critics, steamrolled the prevailing aesthetic scales of values and built its own cast-iron commercial-aesthetic criteria. For example: what sells is good, what doesn't sell is bad. Many are

attracted by that simple commercial formula, seeing in it a chance for themselves. The old communist utopia, in which art is created and consumed by everyone, has been transformed by the modern market into a possible reality.

—from *Thank You for Not Reading*

John Updike

My own style seemed to me a groping and elemental attempt to approximate the complexity of envisioned phenomena and it surprised me to have it called luxuri-ant and self-indulgent; self-indulgent, surely, is exactly what it wasn't — *other*-indulgent, rather. My models were the styles of Proust and Henry Green as I read them (one in translation): styles of tender exploration that tried to wrap themselves around the things, the tints and voices and perfumes, of the apprehended real. In this entwining and gently relentless effort there is no hiding that the effort is being made in language: all pro-fessorial or critical talk of inconspicuous or invisible language struck me as vapid and quite mistaken, for surely language, printed language, is what we all know we are reading and writing, just as a person looking at a painting knows he is not looking out of a window.

—from *Self-Consciousness*

I can only plead that the shape of the book formally approximates, for me, the mixed and somewhat antic experience it was trying to convey. ... Anyone dignified with the name of writer should strive, surely, to discover

or invent the verbal texture that most closely corresponds to the tone of life as it arrives on his nerves. This tone, whose imitation induces style, will vary from soul to soul. … Language approximates phenomena through a series of hesitations and qualifications; I miss, in much contemporary writing, this sense of self-qualification, the kind of timid reverence toward what exists that Cézanne shows when he grapples for the shape and shade of a fruit through a mist of delicate stabs. The intensity of the grapple is the surest pleasure a writer receives.

—from "Accuracy," found in *Picked-up Pieces*

Oscar Wilde

A work of art is the unique result of a unique temperament. Its beauty comes from the fact that the author is what he is. It has nothing to do with the fact that other people want what they want. Indeed, the moment that an artist takes notice of what other people want, and tries to supply the demand, he ceases to be an artist, and becomes a dull or an amusing craftsman, an honest or dishonest tradesman.

—from "The Soul of Man Under Socialism"